BORDERLESS

BY
VIJALI HAMILTON
www.Vijali.org

~BOOKS~

WORLD WHEEL
One Woman's Quest for Peace

OF EARTH & FIRE

LIBERTY
Enlightening the World

LISTENING TO STONE
Awakening to the Spiritual in the Natural World

~FILMS~

LOVE • SING • EMBRACE
Among the Mystic Baul Minstrels of India

WHEEL OF THE WORLD
One Woman's Creative Journey for Global Peace

THE WORLD WHEEL JOURNEYS
One Woman's Quest for World Peace

SPIRIT OF STANDING ROCK

OF EARTH & FIRE
Poetry and Music

~CDS~

AWAKEN YOUR HEART FROM ITS ANCIENT SLEEP

SACRED CHANTS

LOVE SONGS TO THE EARTH

BORDERLESS

Poems Essays & Drawings for a New Mind

VIJALI HAMILTON

World Wheel Press

Santa Fe, New Mexico

ISBN 978-0-9789055-4-5

Cover and book design by Author

All arts depicted in the photos are
copyrighted by Vijali Hamilton

Printed in the United States of America

To order books contact Amazon or
World Wheel Press
info@WorldWheel.org

WORLD WHEEL PRESS
662 Alta Vista St, Suite D18
Santa Fe, New Mexico 87505 USA

DEDICATED

to

Our Earth Family

"Vijali has written in just a few laser-like words what ecological philosophers and spiritual teachers take volumes to convey. We are invited to feel the interconnection, the relationships of every living thing to all else: the mystical within everyday reality; the Spirit within Mother Nature. This is a meditative experience."

— Andrew Beath; Author,
The New Creation Story

CONTENTS

III
SUMMER FRUIT

I V
HARVESTING WISDOM

FOREWORD

Never before in our collective memory have we experienced how the actions of every person affect life everywhere. Now, as I write this in the midst of the coronavirus pandemic, we are experiencing how we are indeed one family striving to live together in our one and only home—the Earth. My personal wish is for all of us to see clearly the interconnection of all life and to always remember this in our hearts, minds, and actions in the years to come. This is my sincere hope for awakening peace and understanding among families, communities, countries, cultures and religions.

My adult life has been dedicated to fulfilling a dream which I had in 1986. In it, I beheld myself circling the planet with my environmental stone sculptures and other forms of art to elicit a world family of peace and understanding. I have worked this way now in twenty countries creating community prompted by this dream which I call, the World Wheel, Global Peace Through the Arts.

I have now entered my eighties and sense a quickening of spirit, which allows every day, hour and moment to be ever precious and meaningful. It is a borderless state that wants to embrace all people, all life as equally important. A deep passion has arisen to share those experiences which have meaning and have touched upon that connecting cord, that universal thread drawing together not only each of us, but all life on this planet, into one living, breathing organism.

I carry in my heart a deep longing to share with my world family the great beauty as well as the sadness that has shaped my life, the darkness and the glorious light that has been gifted to me, and the universal psalms of peace and health we must intone for our planet. These offerings of poems, drawings, and short personal essays are just such moments of the soul's longing for union with the essence of life and its source amid the joys and sorrows along the way while uncovering that jewel residing within us, waiting to be seen.

Vijali

TRAVELER

Oh
traveler
are we not
on the same
journey toward
waking up that spark
of Divinity within? Colorful
are my companions on this road
with flowering purpose, each petal
of a different hue. Each shape and size
varied as the flowers in spring. Each longing
rising from the same heart stem, but radiating
a different color. How I love you all—my family from
one Mother Earth, one Father Sky, journeying under the one Sun.

I

WINTER DARKLY

ANCIENT VOICES 2022

Here I sit in my yurt on forty acres overlooking the Galisteo Basin outside of Santa Fe, New Mexico, in the USA. With its 360-degree views, I can see our sacred mountains holding ancient wisdoms, beckoning us to listen, to pay attention to the signs that the earth is giving. On this very spot of earth the ancestors to many of the Native American Pueblos here in New Mexico, walked, raised their families, hunted the deer and elk for their food. I can hear their ancient voices calling us to respect this earth, to respect all life forms as our brothers and sisters, as our healing of today. I give my word and my actions here as a response to this calling.

What new life will fill the space of the unknown numbers of people who are leaving this earth because of Covid-19? What new relationships, new loves will bud out of this soil? Will there be a solution for the takeover of plastic polluting our waters and earth, choking the dolphins and sea life, clogging our rivers and drainages. Will the ancient species of fish and fowl survive these short-lived humanoids?

Each day I live with these questions, these thoughts, these possibilities. Can we change our lives and habits to not consume more than what is needed, to live within our means, to find balance and harmony with each other, and with all life forms in our earth family?

There seems to be a center forming inside of me, a center of stillness, a center of desirelessness, a center that says it is alright not to know the future—it is the borderless void, the black hole within us, and the black hole in the universe of not knowing, but full of all possibilities. And I am open to those possibilities.

1. Ancient Voices

PEACE BY PIECE

Peace comes tip-toeing

through the rubble of war,

one person at a time,

one piece at a time:

one smile to a Ukrainian neighbor

who lost her son,

one tree at a time growing new leaves

from twisted burnt bark,

one song from a robin building her nest

stick by scorched stick,

one hammer in hand to repair

a shelled house,

one glass of water in a Mariupol hand

to quench thirst of a Russian solder,

one sandwich shared

for two hungry stomachs

from two different worlds.

Peace by piece, peace by piece.

Santa Fe, New Mexico

3

FIRE POEM 1

My sadness
is not from red tongues licking
at the skylight well,
made of willows gathered by my hand.

My sadness
is not from the crackling timbers
that were cut and gathered
from the mountains at La Sal,
stripped of bark to smooth pale flesh,
nor billowing black smoke
vomiting her undigested meal
across white polished walls,
that were curved so fine
as if pottery, turned by hand.

My sadness
is not from the straw bale's demise,
nor melted sky-dome,
nor the death of books
signed by friends with love notes
that turned to cinders—
but that, you,
you, would not be walking in
that front door arched to greet the rising sun.
You, you, would not be there,
friend, unknown lover—you.

Castle Valley, Utah

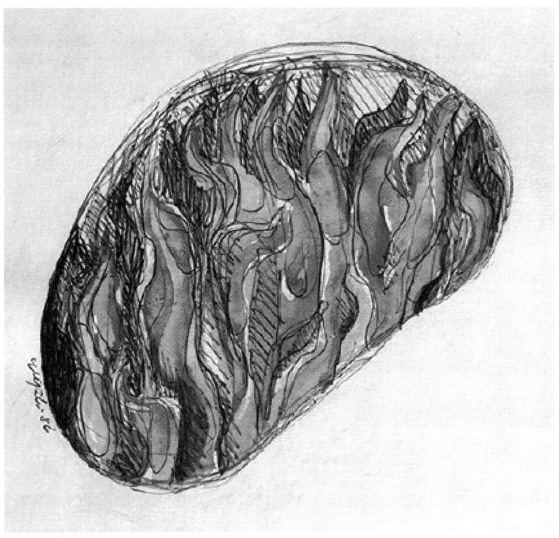

2. Agni, Fire

3. Allen Ginsberg

BLAZING TRUTH

The days are short. My personal needs are great;

to find a home to take care of my dying
one-hundred-year-old father—
Reverse Mortgage is turned down.
No money to convince the solicitor
that I can pay insurance monthly.

My years are short. The planet's crying needs are great;

our children are starving in every country.
Prejudice is rampant in every city, in every nation:
men over women, light skin over dark, business over arts,
money over education, winning over compassion,
and our planet with all life upon it is quaking from global warming.

Allen Ginsberg my dear friend, I miss you,
miss your blazing truth, your fearless reality,
your wild voice of humanity's beating heart.
Where are you now when we need you?

Santa Monica, California

GRANDMA HAD SOMETHING TO TELL ME

Grandma had something to tell me.
She was extra cheerful. When she was worried
she hummed a tune under her breath to hide her feelings.
She took me on her lap. I begged,
"Tell me a story, tell me a story of the olden days."

"No," she said. "I have something else to tell you.
Your mother has been committed to a mental hospital.
She has been diagnosed as schizophrenic."
The words were too big for me.
But Grandma continued. "She thinks she is the Virgin Mary."
I could not understand why that was so bad—
I often played that I was Cinderella, or Snow White.

That night I prayed before going to sleep:
"Dear Jesus, please take my hands
in exchange for Mommy getting well."
My hands were the most precious thing I owned
because they could paint and draw.
I fell asleep with my head on the pillow
dampened with tears.

Next morning, I ran out the back door
and through the tunnel of tall grass
that hid my secret spot from the house.
I sat down with tears streaming down my face
in the circle of stones that I had placed the day before.

Then all of a sudden, a soft light hovered around me
that touched me gently, as if fingers of the unknown
were letting me know all was in place
in the larger family of things. My tears dried
and a yellow butterfly alighted on my hand.

Los Angeles, California

IN THE DAYS OF UNCERTAINTY

In the days of uncertainty of Covid-19
may my innermost being stand steady.
You are my only shelter and peace, you are
my only guide, you are my only freedom.

In the days of ventilators, hallucinations
of our worst fears arise, but will I have
strength to say no to that journey
and yes to the journey of possible death.

In the days of sickness and fear
will I hear the call of eternity?
Will some inner base of myself arise
through fire and smoke to still breathe life?

In the days of loss and despair, may I see the
rise of consciousness galloping like a blazing horse
through fog of leaderless confusion
to a basic love and truth of all life.

In the days of search for new ways to connect,
new ways to show love—may I gather
new voice, new vision, fresh ways of being,
new purpose of love, embracing all life as my own.

Santa Fe, New Mexico

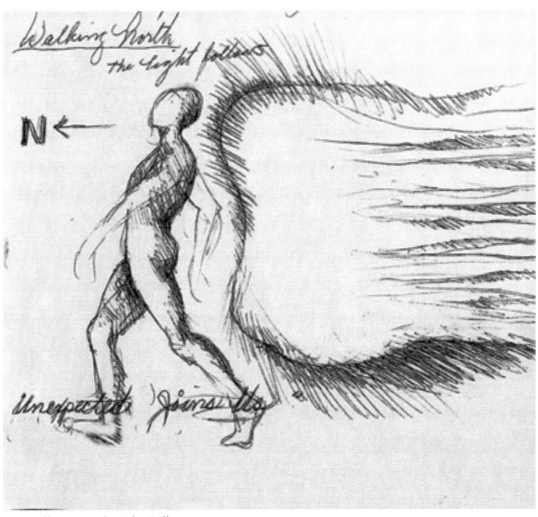

4. Walking North Light Follows

LAVENDER MORNINGS
(song)

Up in the early lavender mornings while
birds are still sleeping and sun's too lazy to rise,
the stillness awakens a prayer for my neighbor
to find cash for rent and a basket of fruits.

His sister's on ventilators sick with the virus,
while the government's quaking with greed.
The North wind is blowing our sorrows
over the land and over the seas.

I can feel greed crawling between sheets.
I can taste it on tongue and its fist in the breeze.
The water is poison and death's in the air,
blood's in the oceans and blood's in my hair.

Let us learn our lessons from indigenous peoples
to live lightly in time and lightly on Earth.
Please sing me the song that lifts and transforms,
that washes my heart and pours joy in my soul.

Of the spirit in trees and the spirit in sky,
the spirit in you and spirit in me connecting us all
as one hive of bees working together to make honey
and love that a long time ago bore you and bore me.

Santa Fe, New Mexico

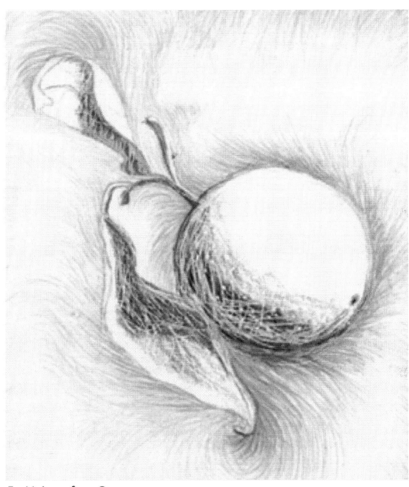

5. Voice of an Orange

LONGING FOR THE WILD II

Walking on the path to the Grandmother piñon pine
I hear the great voice of thunder beings calling
to live the sacred, to find the primal wild again.
Night creeps across vermillion plateaus
as I hear coyote's song, "We are here, we are here."
In lightning flash I glimpse my face across ravines,
a face forgotten until this moment.

In deep sleep under the ancient tree
I taste the salt embedded in soil from eons of seas
that formed our blood,
and touch red earth that formed our body.
On waking I muse; wild spirit you cannot
be found within the fuming cities
crossed by freeways and cemented streams,
or the tortured earth fracked by companies for oil.

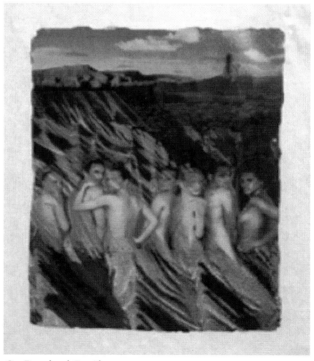

6. Fracked Earth

In early morning I walk in sandstone silence.
By noon my listening feet find rivers cutting corridors
of red rock canyons and crashing water falls
that beat out again that fierce song of the wild.
By afternoon I feel the piercing heat
of sun on back that draws out memories
of that molten core of earth's hot streaming fires
bursting upon the waters, that wild lovemaking
which birthed life out of the rivers and seas.

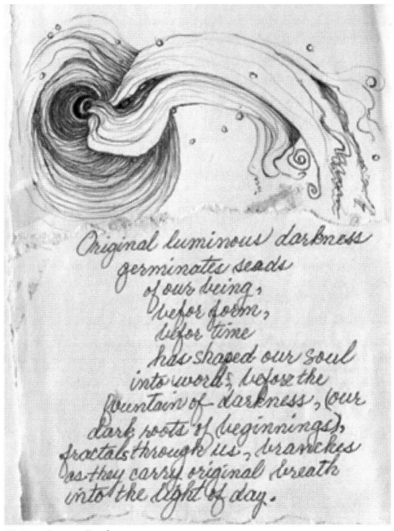

Original luminous darkness
germinates seeds
of our being,
befor doom,
befor time
has shaped our soul
into world, before the
fountain of darkness, (our
dark roots of beginnings),
fractals through us, branches
as they carry original breath
into the light of day.

7. Luminous Darkness

JAMMAL SHEIK

The Sufi greets me at the door
as if he had been expecting me,
as if I am his dearest friend.
It is the first time we have met.

He is elderly, with gray beard and hair,
and a sad but kind face.
He is wearing a long white tunic
over his tall, broad frame.

"Come in, please sit in our
humble home and have tea with us."
In a few minutes his wife comes in
with sweets and steaming tea
on an elegant silver inlayed tray.
Incense burns and soft Palestinian music
floats in from adjacent room.

While we eat, Jammal Sheik
speaks with tears in his eyes.

"Yesterday a Palestinian boy,
my neighbor, was tortured,
then murdered in our Mosque
by an Israeli man. Blood flowed
like a river covering the marble floor.
His screams were heard carried
by wind over the Mount of Olives."

Jammal turns to me as he speaks,
"Beloved, what are YOU doing
to stop this river of blood?"

As I depart his words encircle me—
an arm tight around my heart.

Mount of Olives, Palestine

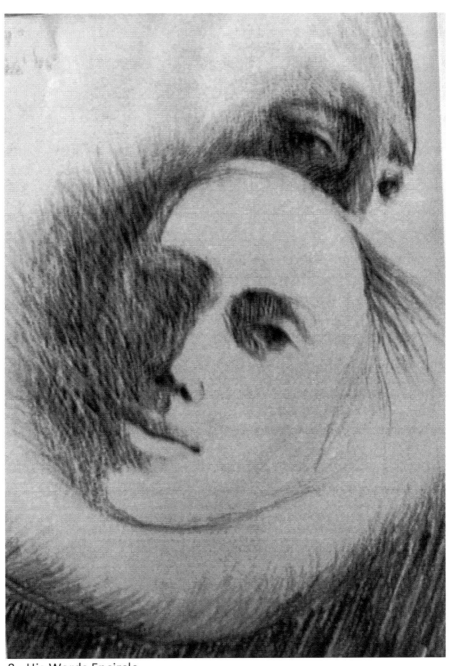

8. His Words Encircle

I HAVE MADE THIS CHOICE

written during the Women's March, January 21, 2017

Why am I here today? I have made this choice
to walk freedom every step, to break limits every day.

I want to meet my brothers and sisters
as I walk in the valley of darkness,
as my song is pulled from my heart,
as my feet are wet with blood and shame.

I look in the face of sorrow and see my own face.
I love this world and choose to be here, choose
my own suffering, choose my own conflict.
I don't need to go to heaven to find the Beloved.
I have found my loved-one in you and in you.

I am a woman. We are powerful
and have a special purpose now, because
we weave together and nurture,
because we don't birth war.

Rise up, lift, embrace the world. Today everyone counts.
There are no kings, no peasants. Everyone is responsible.

No coming of Christ to save us and our endangered planet.
No beings from outer space to protect us from war.

We must save ourselves by innate goodness within us
rising to love each other, embracing our differences.

> We belong to each other,
> to the whole world.
> We become the creators
> of our own destinies.

Santa Fe, New Mexico,

IT IS MURDER

It is murder.

The trees are filled with white blossoms

looking innocent in their silk petals.

The fires rage.

In the shadows of 400 years of systemic racism

White America loots Black People.

Rivers dry.

Whales beach on white sand,

and dolphins chock on white plastic.

My vanishing country dies

while the president combs his hair.

Anger rises

to see the Divine murdered on the cross

by a knee on the throat.

The Holy is massacred. I can't breathe.

With his last breath

"America the Beautiful" tumbles and crumbles into dust.

Inspired by:
Women's March Activist Tamika Mallory,
Keenanga Yamahtta Taylor,
Bakari Sellers, Cornel West

LOS ANGELES
December 2008

*H*ere I am, back in LA, my birthplace, and the birthplace of my father, wanting to find the burial site of my mother, (among unclaimed bodies of LA County), find that street, and maybe the house, where my father and mother and I lived until they divorced—I was two years old. As I drive into the city my truck breaks down in the middle of traffic, and I sweat out a two-hour wait for a tow truck to pull me to a garage.

As I wait I read in the LA Times that in a single night in California there are 157,277 people who are looking for shelters to spend the night. And in 2008, Los Angeles shelters house only 40% of these people. But what of the numbers of people who don't find shelters and are on the streets? I know that a large percentage are mentally ill, as was my mother. In the 1940s when she was committed to the Metropolitan State Hospital, it was difficult to get discharged from hospitals. She ran away three times, but was brought back each time for shock treatment until she was ultimately brain-damaged and thus became pliable. Now, in 2008, it is hard to get people into a hospital and to get the proper medication. The Bush administration has cut back funds for mental hospitals and schools in order to pursue war. The streets are where the mentally ill end up—some dying from the cold of winter without shelter, some from malnutrition. And what about the youth? 40% of the people who are homeless are under the age of 18 years! What have we done?

My car is running again and I drive on through downtown, through towering buildings holding $689.18 billion in wealth, I read earlier.... and on the streets below, I observe as I drive, are the people who don't have money for the high rents, who are perhaps mentally ill and have to find plastic tarps, grocery carts, string and anything that can tie together a shelter from rain, sun, and wind. My heart aches as I drive away from this scene to find the street where I had rented a tiny room on the second floor of a family's home.

I sit on the twin bed that belonged to their daughter and look out the window onto a quiet side street, one block from roaring Wilshire Boulevard. A few scraggly trees separate me from the apartment on the other side. I have left the silence and spaciousness of red rock Castle Valley, Utah, with views of the snowcapped La Sal Mountains, two miles from the fast running Colorado River in the Canyonlands—to venture into the mouth of the dragon.

My body feels alive, the way it does when I am in the present finding creative solutions for what I find in front of me, for what my heart has been called to. I found three services on the web that work with homeless youth. One is Lamp Light Community, which gives housing and medical care for the street mentally ill in the skid row area of downtown Los Angeles where I had found myself just the day before. Bravo! But how many of the homeless have access to this caring service of the Lamp Light Community?

9. Youth Who is Homeless in LA

I can't believe that a city like LA with all its money and possibilities has so many children that don't have a roof over their heads or food. This afternoon I talked with many organizations that work with the youth to see what is done. I want to volunteer but they make it hard, fingerprints, $100 to have a life check on your records, etc. But I need to keep trying. The St. James Center in Venice will let me volunteer in the summer with abused kids. They are not the youth who are homeless, but low-income children. I am proposing to them that I start a homeless program with the arts, but they can only talk to me after the Christmas holidays.

~~

It is Christmas Eve day and I am giving out blankets, mats, and sweaters to the homeless children on Venice Beach, their hangout. I am scheduled to give a sculpting class to them through the OPPC (Ocean Park Community Center), an organization that works with the homeless youth. I brought my sculpting tools and alabaster stones from Utah for this purpose. I have already received a donation of $250 to buy more blankets, etc., so I am quite excited about it. I have a team now of interested and talented friends; artists, theatrical performers, dancers from my former life as an artist in LA who want to participate. This morning at the beach I had a very interesting conversation with one fifteen-year-old girl who was homeless—very bright with her own philosophy about life, very positive. I decide I like these kids' company, maybe more real than the so-called adults. I will be preparing food on Tuesdays with this same organization. I want to keep volunteering with as many organizations that I can to get information and skills, which I don't have.

I am leaving my rented room at the end of my one-month stay. The family is wonderful, but the $700 with shared bathroom and no kitchen, isn't. I will just stay with friends. One friend has offered for me to stay two weeks. We'll see what happens after that. For $700 I could put one well in an African village and repair 4 roofs in India. My viewpoint of money is so different from the people here in LA.

Today, I am going to a few thrift stores to buy more blankets and try to find inexpensive sleeping bags, which they like better, as I am told by one young boy with a halo of curly sandy hair. I keep these in the back of my truck so that when I see people on the street, I can stop and give them out. Tomorrow I am cooking with the OPCC. The work is growing step by step, and I am learning from organizations as well as just going out into the streets and talking with people while giving out things they need. When I gain a little more experience I want to hold classes at Venice Beach. Another idea comes to me, which is to ask some of the men who are standing on street corners with signs for work to give them a little money to work along with us. I was asked, "How do you start?" I can only say that I just respond to what is right in front of me. I just follow where my heart tugs me.

Vijali started her art classes through the OPCC (Ocean Park Community Center) where she and many talented friends offered their time and heart for a number of years.

10. Man On Street Corner

WHY HAVE YOU FORGOTTEN ME?

You stand on my earthen body, drink my crystal water, eat my mangos
dripping from trees, build your homes from bamboo, clay and thatch.
Now listen to the wind that whips through my forest hair calling you.
COOOOMMMMMMEEEEEEEE, LISSSSSSSSTTEEEEN, LEEAARRNNNN.

Listen, I am calling. Listen. But you don't see my signs, heed my words.
I stand in one place, grow, die and am born again and again.
You have taken my limbs for endless paper, spoiled my rivers with
factories and oil. Clearcutting, you have destroyed my ever-new life.

Speak to me. Come listen to my song, voice of condor, toucan, and parrot.
See the beauty of my face as jaguars slink into shadow, baboons nurse babies.
I am your lover, giving you all I have, my body, my soul radiating within all life.
I take care of your children as they breathe fresh air, as they drink pure water.

Boys and girls run through my copal and papaya trees laughing and playing,
are fed by yucca, mango, potato and fish, monkey and wild boar that you love.
I pour knowledge into their minds and hearts as they watch life stir around them:
see the wisdom of ants and beavers and bees. Why have you forgotten me?

Amazon Rainforest, Ecuador

THE HOUSE FINCH

Here he is. First I see a beak protruding,
then his red head and chest and pull him out all grey
covered in ash, feet curled, wings by his side—so still.
My heart sinks, how long, how long,
has this house finch laid in the old wood stove

after tumbling down the smoke pipe—
unable to get out, unable to eat, to drink,
unseen until the cool days creep in
and my need to be warm, build a fire, prompts me
to open the iron stove door—and here he is.

Something prompts me to look up from my musing
and out the window I see a female house finch
sitting on a dead branch of a juniper tree
looking through the window of the cabin.
She stares into space through the glass. My heart sinks.

How long my dear little one, how long
have you been waiting for your love? I look down
at the little bird. He fits perfectly in the palm of my hand.
I dust him off, so soft he is, and lay him by my side
on the night table and begin to read.

In a few moments, the sun
pulls me away from my book
and the same little finch catches my eye again,
brown wings, golden white breast,
sitting patiently, looking through the window.

How long my dear, have you been waiting.
How long has your heart cried out for your mate.
How long has your nest been full of miniature blue eggs,
the size of my finger tip, with no one to bring you food
while you incubate your eggs to birth a new family.

How long have you been waiting on this dead branch
for your love, who will never return to you.
How long does the heart cry out without an answer.
How long do we all have to wait before the heart
is healed and filled again from the loss of a loved one?

Los Cerrillos, New Mexico

11. Forgive

24

PLEASE FORGIVE

The room had that unpleasant hospital odor,
there were no pictures on the walls
and the furniture was made of gray plastic.
Through a little window in the door
I saw my mother walk slowly down the hall.
A warden opened the door.

She came into the waiting room.

She was not at all as I remembered,
heart-shaped face and graceful body.
Now she was heavy with a puffy red look,
scar on her cheek, teeth gone, eyes glazed.
She moved stiffly, not looking to right or left.

We walked to the lawn outside and sat on a bench.

After a long time of silence
Mommy turned to me and for the first time,
that I can remember, looked into my eyes. She said,
"Please forgive me for what I have done to you."

She never looked or spoke to me again.

Metropoliten State Hospital
Los Angeles, California

25

WHAT BORDERS DO WE HAVE

What borders do we have

when forests disappear in the Amazon of Brazil by encroaching farmers,
when climate change rocks our planet into disasters of floods and droughts,
when water is no longer fit to drink and poisons the fish and kills the coral reefs,
when air is no longer healthy to breath and we die in the throws of emphysema,
when elephants, rhinos, our animal cousins, are tortured by sawing off their tusks
to sell in the black market, and left to die through hours of agony—tell me friend,

what borders do we have

when our children are taken for slave labor, as sexual commodities,
when women's bodies are raped in the Congo as spoils of war—
as a woman do I not feel raped in my own body too,
when nuclear accidents plume poison over our own shores
our earth, our air, our wombs, and babies are born
without legs, without arms—are not these our own children,
when girls are sold for profit as sexual slaves at the age of seven, locked in a cage
for the rest of her life—is she not my own daughter—tell me friend,

what borders do we have

when children are dying from starvation in every country,
even in the professed free and wealthy USA,
when indigenous children are taken from their families,
forced into boarding schools—only to now find thousands of their
starved bodies buried in the ground under schools and churches of a religion
forced on them by way of beatings and slavery. These troubles, every one,
are not distant from us, they are embedded in our hearts—tell me friend,

what borders do we have?

San Francisco, California

26

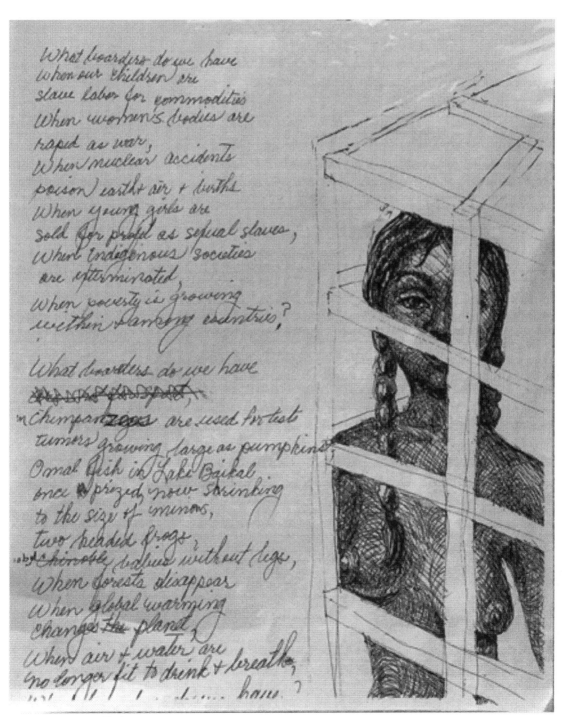

What boundaries do we have
when our children are
slave labor for commodities
When women's bodies are
raped as war,
When nuclear accidents
poison earth, air + births
When young girls are
sold for profit as sexual slaves,
When indigenous societies
are exterminated,
When poverty is growing
within flourishing countries?

What boundaries do we have
~~when nature itself~~
Chimpanzees are used to test
tumors growing large as pumpkins,
Omul fish in Lake Baikal
once prized, now shrinking
to the size of minnows,
two headed frogs,
~~abnormal~~ babies without legs,
When forests disappear
When global warming
changes ~~the~~ planet,
When air + water are
no longer fit to drink + breathe,

12. Human Trafficking

I PROMISED ON A STAR

Born out of earth I knew
that grownups forget along the way.
When I was five I promised on a star
that I would always, always remember.

School time came
and shadows fell across my path
and inside storms rearranged my cells.
The body swelled.
The red earth stained...
and everyone stared and whispered.
Grandma tightened lips and looked away.

Snow fell,
covered earth with white
as asthma filled the lungs. Sick,
inside the bedroom grew the
shadow trees and shadow clouds
and shadow friends.

Years later I remembered
my promise to my family
of the earth; those wild animals,
my friends, with love just like we have,
those insects busy with their work,
just like we do, those sorrows
with the death and loss of child and friend,
just like we have, I remembered all.

Arcosanti Ranch, Arizona

13. Embrace the Unknown

FROM A DARK WOMB
(song)

I was born from a dark womb,
passed through many lives
finding my way to stand,
finding my way to walk.

I gather the stars for my eyes.
a gift from the earth my body
as I walk through the valley of life,
as I walk through the valley of death.

I am Sita, I am Durga and Sareswati
I am Ravana and wear a dark cloak. I
walk on the edge of time between
the abyss and sun.

I gather the wind's dark breath
into my belly, into my womb
as the world turns in sorrow,
as the world weeps her tears.

I am Sita, I am Durga and Sareswati
I am Ravana and wear a dark cloak.
I walk on the edge of time between
the abyss and sun.

Santa Fe, New Mexico

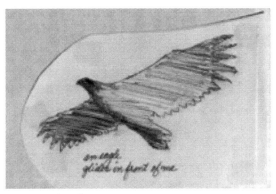

14. Eagle Flying West

REMEMBRANCE
OF THE BIRD PATH

What part of us remembers
our path of the bird, remembers
the freedom of flight, that ultimate space

when the tethers of restraint
are loosened like worn out clothes
disintegrating before our eyes

and we are set free for a moment
as our breath deepens and
a resonance of knowing takes over.

Without effort our wings spread
with remembrance of flight
on the tips of our feathers,
in the muscles of arching neck and back
and our soul flies ahead of us
opening the way with a joy
of boundless freedom.

But the dream evaporates
as we are caught in the
sheet's twisting knot
at the break of day.

Santa Fe, New Mexico

MEDICINE BUNDLE

For Deena

Herbs tied in Chinese silk

were given to me by a Siberian shaman for protection.

They will protect you from past habits

that you wish to leave behind.

Pine cone and pine needles

from Siberian forest which covers more than 1.6 billion acres,

three times the size of Brazil's rain forest has arrived in your hands

to bring scent and beauty from afar into your home.

Stone from Lake Baikal

which contains almost 1/4 of the world's fresh water

is more than one mile deep

and is the deepest on the earth and the most ancient—

this stone rounded by water and time has come to your home

to remind you of New Life you have entered

filled with time and space, drawing into its vastness

the moments of surprise and continual new life.

Blessings on your new journey

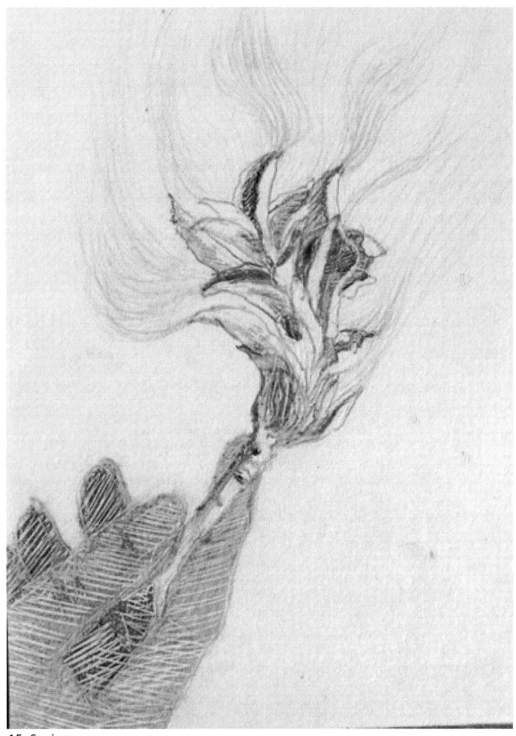

15 Saging

II

SPRING BLOSSOMING

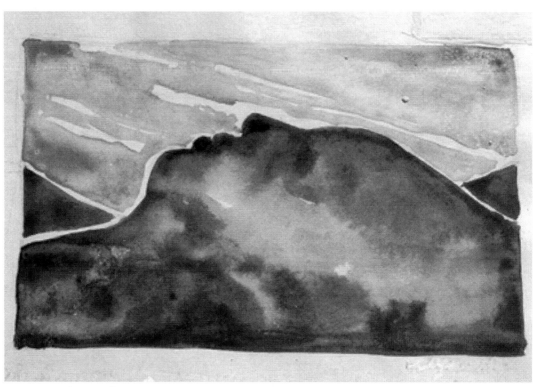

16 From the Earth

EARTH AS SACRED SPACE

I flew! The thirteen hours of driving from the Hopi Reservation seemed like three. The spirit of the Kachina dances, the rhythm of the drum, the earth's heartbeat still surged through me. But as time passed on the road, I could see and feel the light buoyancy of the northern Arizona air thicken and congeal around me as I drove into the Los Angeles basin. Breathing became an effort. My shoulders tightened. Heavy, brown smog obscured the horizon. My car joined the growing swarm on the freeway, pressing forward relentlessly as if herded toward our destiny by some unknown slaughterer. As I turned off the freeway, high-rise buildings enveloped me, blocking out the sky that had been so close to me on the reservation these last few days. I looked out the car window. People appeared sandwiched between smog and pavement. "How absurd! What am I doing here?" wailed some indignant voice within me. "Where is our power place, our Hopiland filled with meaning, our mountain peaks to summon the Kachina spirits? Where is OUR spirit-based community in Los Angeles? Where is OUR sacred mountain?"

Days passed. Early one morning, before sunrise, I sat up in bed with a start. "Yes, we do have our sacred mountain," I thought out loud. I remembered the first time I laid my eyes on Boney Mountain, its backbone of twelve-story high stone pillars rising like a row of deities. It was love at first sight.

I jumped out of bed, grabbed my sleeping bag, climbed into my car and drove toward the Mountain, pulled by the spirit of this sacred place.

Driving up the long, winding earth road, I thought back to the Chumash medicine man who had told me that this peak, the highest ridge in the Santa Monica Mountains, was the power place of this area. The range runs east and west, sacred directions for Native Americans. I found the cave I remembered from my last trip, a cave filled with Chumash pictographs, and prepared to stay the night in quest of my own way to live in harmony with the earth.

The mountain gave me an answer. I stayed on Boney Mountain from 1982 to 1987, trading the comforts of my Santa Monica home and the companionship of my husband to live alone in an abandoned trailer. My life took on a new simplicity. I began to synchronize with the rhythms of nature. Each morning I rose early to greet the sun from a high plateau and at the end of each day I returned to wish the sun farewell. Every simple act became a ritual—hauling water and bathing outside using a bucket and ladle, gathering wild greens for salads and sage for tea. I made peace with the rattlesnakes that lived beneath my trailer, and the bobcats and mountain lion that roamed nearby.

By living close to nature in this way, Boney was transformed into sacred space for me. I believe that a sacred space may be any place, not just ones designated by our ancestors. We may create them as I did on the Mountain by entering into the spirit of a place through simple actions performed in a reverent way. Every object of my daily life took on a special meaning. The trowel I used for the toilet was as sacred for me as a chalice used in communion.

Even as a child I knew the sacredness of personal space. I remember going behind my grandmother's house in Dallas to a place where I could hide behind tall weeds. I would sit for hours in my circle of stones. As a ritual I placed dandelions and honeysuckle blossoms

on the ground. That space was so special I never revealed it to anyone, not even my closest playmates. How comforting to be there by myself as I mourned the death of a girl friend or wept for my mother and father who had abandoned me at the age of two.

Sacred spaces can be created even in cities. In the late 1970's I felt a need for a sacred simplicity within my Los Angeles home. On a sudden inspiration, I took everything out of a closet and painted it white. Within this purified space I placed a stone, a leaf, a bowl of water and a sitting cloth from the Amazon, things special to me at that moment. I had created my own sacred space, my power place right there in the city.

For me as a sculptor, the process of carving and painting is itself a ritual. When I became frustrated with the commercialism of the art scene in Los Angeles, I closed my studio and started carving stone outcroppings in wilderness areas. The first one was the Winged Woman carved in the Simi Hills outside of Los Angeles. I found a group of large sandstone boulders that suggested a woman's face and a wing. Beneath her lay a stone shaped like a man. By the time I completed the sculpture, I realized the woman reflected the need for feminine spirit to emerge in our society. One day I returned to the Winged Woman and found people sitting in front of her and meditating. I realized, then, that art can be used to create sacred spaces.

Prompted from a dream during my five-year retreat on Boney Mountain, I began an art project of creating sacred spaces through sculptures and performances at twelve sites circling the globe. I hoped these would help recall communities around the world to the sacredness of the earth itself. Boney had taught me that a sacred space was not just a personal power site, but that the whole earth is sacred ground. It no longer seemed enough to sit on a stone and feel the interconnectedness of all life. The need to transfer the experience of a private sacred space to all of nature led me to begin the project called the World Wheel: Global Peace through the Arts where the whole world became my home, each person, each animal, each plant became part of my World Family.

My journey has taken me from Malibu to the Seneca Reservation in upstate New York, to the Alicante Mountains by the Mediterranean Sea in Spain, the Umbrian forest in Italy, Tinos, an island in Greece, the desert of Egypt, the Dead Sea in Palestine and

Israel, a tiny village in West Bengal, India, Shoto Terdrom in Tibet, Kunming in South West China, Lake Baikal in Siberia, and the first wheel culminated in Japan. I have now begun a second wheel around the planet running through the Andes and Amazon of Ecuador, Senegal of Africa, India, Australia, the Republic of Georgia; and this wheel of touching the sacredness of countries continues on today.

While staying in Ecuador, I worked with the entire community of Peguche to celebrate Achilly Pachacamac in a unique stone sculpture which expresses the spirit of the indigenous Andean peoples. Achilly Pachacamac is the pre-Incan name for the supreme God, the life force which encompasses all.

From within this immense stone emerges a single face—that of Pachacamac, representing the integration of male and female essential qualities. The portrayal of Pachacamac also expresses hope for the Millennium: that men and women live in harmony and equality. A rising sun shines forth from the stone, heralding a vision of peace for the 21st century. A crescent moon and the rising sun together further echo the harmony of male and female energies in the universe. An immense ear of corn, ancient Andean symbol, rises up from rich soil at the base of the sculpture, symbolizing nourishment for Mother Earth's children.

On the South face of the sculpture a spiral encircles a Quichua Poem written by Shaman-Healer Jose Quimbo: Tucui Shunguhuan Yuyacpica Cai Rumi Yayapash Rimangami Cai Yucu Mamapash Jambingami. If you look at the stone with eyes of your heart, you will understand that stones speak. And water heals, giving you life.

Another World Wheel experience deepened my sense of how art can contribute to making a place sacred. In May, 1992, I created a painted relief in a cave at 16,000 feet on the Tibetan Plateau in the Terdrom Valley. My Rainbow Bodhisattva, a female figure, is filled with prisms of color and seated in the lotus posture. Her legs are molded from the red clay of the cave floor. Neither a Buddha nor a Quan Yin, this is an energy body. I wanted to create a work traditional enough that the Buddhist nuns and hermits !living in near by caves could identify with it, but I also wanted to embody a universal image that was not limited to any one concept of wholeness. This light-filled figure symbolizes, instead, the underlying energy connecting everything, merging our inner space with the

space around us. I made my Bodhisattva feminine because I was saddened to find the image of Yeshe Tsogyal, the most prominent female holy figure in Tibet, shoved into an obscure corner of the shrine in Shoto Terdrom. It was in the feminine folds of this valley that she had lived in the 7th century for many years in a cave and received her final illumination. I longed to see Yeshe Tsogyal represented in shrines as an equal beside her spiritual mate, Padmasambhava, reflecting that harmony and balance that is so necessary today for the health and continuation of life on this planet.

I did not know whether my creation would be recognized as a sacred site by Tibetans in the area. The answer came on the day I completed my work. Two nuns who were walking in the canyon came up to the cave. When they saw the figure they burst into tears, their faces flushed and they flung themselves face down on the ground in three full-length prostrations. That moment was my reward; I knew that this image had touched something within them that needed to be addressed and that this cave would be for them, from this moment on, a sacred space.

The reverence expressed by these nuns is something most Tibetans carry naturally in their lives. They wear only patched clothes against the freezing cold, but they regard themselves as blessed to live on their sacred land. We have much to learn from them. If I can generate even a fraction of their respect for the sacredness of nature through the process of creating the World Wheel, I will feel that it has all been worthwhile.

Creating art works is not the only way to acknowledge the sacred. Truly, the objects of ritual are always at hand. Stones are altars. Sunlight shining through leaves is perhaps the origins of our magnificent stained-glass windows in churches and cathedrals. Trees are pillars holding up the vaulted sky. Rivers are baptismal waters. Flowers are incense of the earth. I worship the sacred when I lie with my back against the soil, my eyes gazing into the blackness of night.

The World Wheel is my way of walking in the world. It is my way of saying let's expand the idea of sacred space. Let us walk together the sacredness of the earth.

I FEEL LOVED

I
feel loved
for the first time
while sitting on stone
with my animal friends,
with the breathing
of earth against
my thighs.
I
feel loved
for the first time,
watching life stream by;
insects doing their
busy work,
flies
dancing
around my
head, food for my
bird friends' empty stomachs
as they migrate to their
call of destiny.
My
family,
you have finally
let me know what
it means to be alive.
A family I had for so long,
but did not know. I feel loved
for the first time, held
and cherished.
At
night
when the dark
opens up and the light,
from billions of stars, looks down,
I know I am loved. I am loved.
I am home.

Cerrillos, New Mexico

AT HOME

I
sit by
Mother Ganga
as She crashes over stone,
freeing Herself from the dark forest
where I walk early mornings past a naked Naga
smeared in ash tending his dhuni fire at the mouth of his cave.
At home.
The sound of chattering birds, the peacocks crossing path,
the elephant dung piled high, the sound of
streams propelled to the body of
Mother Ganga
by my side—
these bring
me home.
But in every
country I
feel home.
Every place
I touch
the earth
is home.

Rishikesh, India

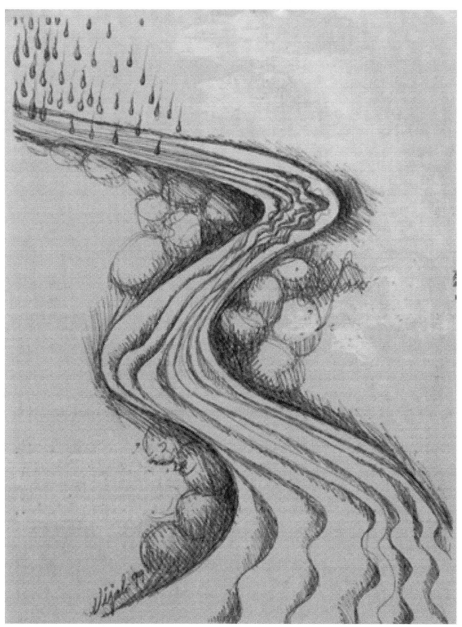

17. Mother Ganga

43

LISTEN

(sing with nature sounds)

I lived as a hermit, alone, at the top of a mountain for five years. If there is any wisdom running through my life in this time, it has come from listening to nature's Great Silence through the stones, the trees, the open spaces, and the wild animals—the pulse of all life being my own heartbeat.

Listen
Listen to the beat of stones
tumbling downstream (bag of stones)

Listen
Listen to the cry of wind
clearing our lungs. (breath)

Listen
Listen to the song of birds
calling us to our own song. (flute)

Listen
Listen to the lightning crack and thunder (hit together
connecting us with earth and sky. one white, one black stone)

Listen
Listen to the roar of water
cutting canyons through our heart. (rainstick)

It is our voice forgotten,
It is our heartbeat of the earth, our body.
It is our eyes, the eyes of all living things.

Boney Mountain, California

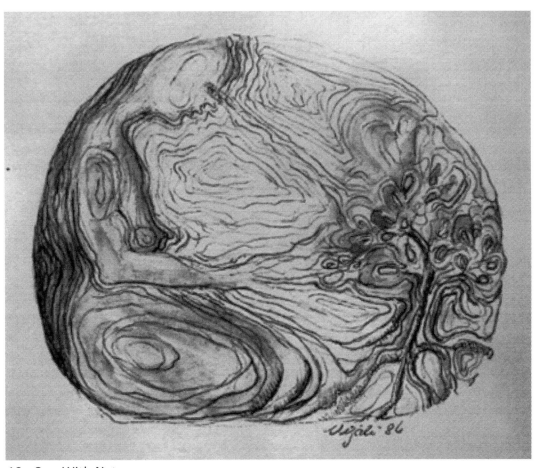

18. One With Nature

THE MEN I LOVE

Deer sleep
as spring warms the days
and my heart moves again
after living with death.
Now, my mind moves to

the men I love:
Father, three months with me
his spirit sours while body shrinks,
then finally he takes flight.

As a child I sent love and tears,
to my absent father,
my absent mother,
but no love was returned.
Absent the body, absent the holding.
Perhaps I learned to love the earth,
because the flesh was absent.

Nature became my mother
Nature became my lover—
stones, pebbles, the trail of insects
in the soft shifting sand,
roots reached out to touch me,
uncovering their secrets.

The men I love:
Perhaps you today
walking in flesh and bone.
You who love the earth the way I do,
seeing spirit in mountains and rivers,
in forests and deserts.

The men I love:
Not god the father in sky above
I have no love for thee out of reach,
but that same spirit I love in men
walking on earth kissing soil and stones
with their feet, weeping as we all weep
when the heart spills tears

for the people we love,
for the uncertainty of life,
for the earth being raped
again and again, gangbang raped
with no meaning just greed
and greed and more greed.

The men I love:
You, Amit Dahiyabadshah
with your voice of truth
even as Covid-Delta
takes your breath
your poetry still speaks
through your pores,
through your will to live.

The men I love:
Chief Seattle,
his heart weeping for his people,
his mind seeing our future
now taking shape before our eyes.

The buffalo gone.
The pure water gone.
The trees in the Amazon gone.
The air filled with pollutants—
and in time perhaps the people gone.

But, what if
What if the youth rise up,
young boys, young girls
with vision so clear
penetrating the lies we live,
speaking the truth, un-televised,
walking the talk, un-spoken,
singing the praises of the sacred, un-sung,
touching our hearts, un-loved,
while holding hands with
the men I love and
our whole family of earth.

Santa Fe, New Mexico

IMPRINT

A deer walks in snow outside my strawbale window.
Inside Dreaming Deer lies close and warm beside me,
penis hard and I am soft as we rock in squishing
love juice mixed with cunt and sperm. Our eyes meet,
masks down, seeing clearly in the evening dark.

Sex is everywhere in nature in all themes.
Sex is chemistry. Sex is electromagnetism.
Polarity and expansion are sexual laws.
Poles attract each other. Stars, planets,
and galaxies in space are pulled by magnetism
are energized to stay entwined through sex.
In our lack of wisdom we have misused
what has been given for our use, for our gain.

So long alone.
His breath surrounds and fills,
bed sheets intrude, memories rise of mother's
warmth, then mother's warmth removed.

And now I lie alone imprinted as in clay,
thighs moist from memory, warm from touch.
Earth Mother shakes Her hips and earth quakes,
her stream of lava long held in the belly of her womb,
erupts in volcanoes, tsunamis rise and belch.
His lips were warm and full and moist as

my memory draws me back into his arms,
mouth to mouth, belly to belly, groan to groan,
warmth penetrates the soul as he unfolds
his layered being with every breath,
every strand of his loose dark hair
linked to pueblo father, grandfather,
their voices breathing through him
only now heard in the stillness of that night.
"Yes, change will come depending on our hearts,
fifth cycle of creation, dawn of light."

And for me, my mother's melodious voice
insane in her saneness finds the edges of my mind
ancestry of madness divine, speaking only truth.

I pull the curtains back and day has found herself.
Divine the nipples rising on my breasts,
divine the knitting threads of scent and touch
upon this altar body of holy sacrament.
The pull and pattern of attraction
running through my cells. How natural,
we give way to pulse of cosmos's sacred play.

Will he come again?
Will memory crank the handle of the door,
brown skin on my pillow, firm hand on my breast,
will this universe find my mate in our millions of galaxies?

Castle Valley, Utah

ECUADOR AMAZON 2002
(journal)

July 26: I spent two days with Camilo in his father's traditional Shuar (Jivaro) house in the rainforest of Ecuador, south of Macas. By American standards his house was a hut, with a thatched roof, sides made from split bamboo slats, more like a fence, which you can see through and peek over, and a door more like a gate. Together we gathered food from the rainforest, the center of palm trees, dug out the roots of the yucca plant, which is the base food in the Amazon rainforest, (yucca means "mother, base"). This time I spent in the Amazon was food for my soul.

Camilo and I plucked large snails (catacolas) out of the pound behind his father's house and fished, bringing up small gold-colored fish whose name I don't remember. I followed Camilo into the forest with his blowgun and darts. He would make the sounds of bird-calls and the birds would answer back. He aimed at something in the dense forest, then blew his dart through the long tapered tube of his blowgun that was probably 12 feet long. To my amazement the dart hit something I could not see it. But I heard a squeal. He told me, as we ran with his 17-year-old daughter Tamara to find the wild boar, that he didn't put poison on the dart because in the evening we were going to eat it with his family. That evening we gathered and had a tasty dinner eating every part of the wild bore; eyes, brain, tongue, even the sinews and bone marrow around and in the bones.

The next morning we watched his cousin, Prima, who was by the pond gathering snails with her baby strapped to her back. Her beautiful child couldn't take his bright dark eyes off of me—this blond apparition so different in color than his family. We all went back to the shack and roasted snails sprinkled with caterpillars, and palm, yucca and fish wrapped in banana leaves, and within fifteen minutes unfolded this precious package to a most delicious dinner.

Night crept around us as we sat by the fire with copal wrapped in a banana leaf tied tightly with a plant cord and lit on the end. This was our torch for our evening light. Camilo's cousin and baby had left us before dark. We sat in silence listening to the evening song of the Amazon rain forest; an owl, other birds I couldn't recognize, the screech of a howler monkey, the Ukius River pushing its way through dense growth that continually wants to enfold.

The next day Camilo's children came, and we played with the children of his cousins, and the day was the repeat in rhythms of the forest; gathering food, rocking babies, now two cousins with babies swung in simple hammocks made from their shawls tied

in the corner of the bamboo slats of this twelve-foot structure. A piece of bamboo was stuck in each corner to keep the space open for the babies.

The coming night brought his father back from his forest orchards of yucca, tobacco, and banana plants. He sang and played songs in the Shuar tradition on his tumak jaw's harp, a single piece of bamboo tied at both ends with a single string that is toned by placing the bamboo in his open mouth and moving the lips. These anents, traditional songs, are usually passed down through the women and are power songs, changing the force field around the person they are sent to. Often they are meant to draw a wandering lover back or to smite the heart of a prospective lover. That night his wife sang an anent so that the lovers of the world would find each other.

At the end of the day my heart wept for the sweet simple life we have lost in the United States and which is disappearing all over the world along with our mother rainforest herself.

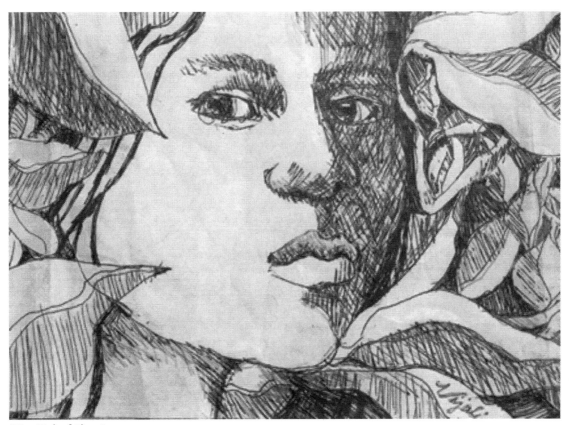

19. Girl of the Amazon

GRAVITY

What is this gravity in my heart
when time stands still and
the world turns pulled
by another magnet
and new eyes
are born.

So long
I have fought
weaving my soul
with another. Now
the infinite breathes
through your lips and
your breath breaks rhythm
to breathe with mine and my
heart cries open, beyond my control.
What is this moment, what is this force
breaking bonds and cementing others? Let
me just rest in the unknowing space of the infinite.

INTIMACY

Intimacy
with the rays of sun,
with the shape of leaf on
the Sangre de Dragon tree,
in the Amazon forest with her
bark smooth, white, unsuspicious of
the blood-red healing sap within her branches.
Intimacy
yes, with death—
a friend's death in Ecuador,
her body cold, we wash and dress,
lie her in her final bed, the coffin, silent, still,
while her soul is journeying alone to find her new home.

Amazon, Ecuador

20. Transformation

21. Meeting by Cave and Ocean

MOUNTAINS NEVER MEET

Mountains never meet, but today we meet by the sea,
 walk in the edge of tide looking for shells and tumbled stone.
I reach out to lead you by the arm to the red rock glistening at the water's edge.
 You hold my hand, come patiently to the silence between new friends.
This private beauty, shy presence of our souls inhabits the warmth of your hand.
 The longing of earth blows across surface of land
 as we kiss for the first time lying in sand.
Waves of ocean sound roll over us with compassionate listening.

As we drive through the mountains on winding narrow roads
 the silence of stone and vistas of ocean come to awaken us.
The dream of the heart is now. We have time
 when the day becomes simple and destiny unfolds,
drawing us back into our gentle solitude to the dream of our souls,
 as children approaching the threshold of possibilities
 at the hearth of our heart.

We hike to the cave sculpted by fingers of wind,
 pounded by rain and baked by sun offering to us new vistas.
As we sit in silence I know my form grew out of the mountains I love.
 My breath came from the wind circling as the sun moves across sky.
And you? The darkening red sky enters you, surprises you with your own beauty.
 Our souls are at home.

Santa Barbara, California

55

LAVA FLOWS AT OUR BACKS

We sit in the stone shelter
overlooking blue shadowy
mountain outlines of the
Sangre de Cristo Mountains
telling life stories as rainbow
light dances round us.

Ancient lava flows at our backs,
desert varnish blackens
through hands of time,
native voices etched in stone
shout to us on the breeze,
"Spiral emergence is now."

Skin to skin, blood to blood,
bone to bone, eye to eye
song to stone, earth to voice
as we leave the rocky ledge
knee to elbow over boulders
our hearts filled with gratitude.

We enter your temple of house.
Bellies fill with saffron colored rice.
Music enters our pores as
your songs speak of the
turning wheel of life:
of accents, drumbeat stories
layered in cultures like geological
shifting plate tectonics
coming together, overlapping,
then drifting apart.

A kiss at end of day;
what volcano erupts,
what shape emerges when
lava flows, spreads her fingers
gathering stones to embed
in her flesh—then cools into form.
This moment is mystery,
two lives coming together,
taking shape by hands of earth.

La Cieneguilla, New Mexico

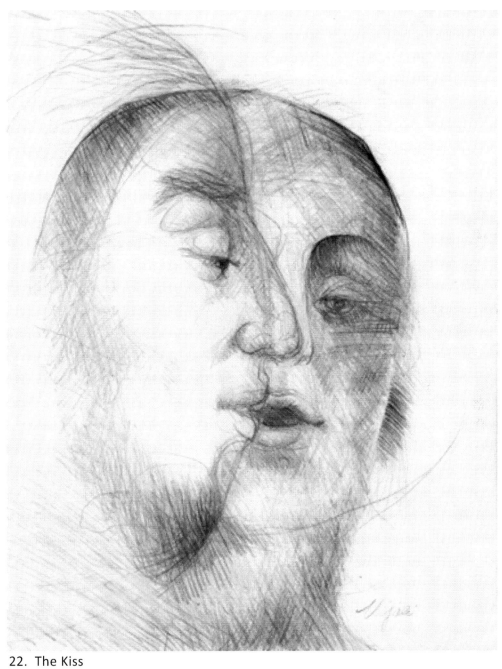

22. The Kiss

23. Man Experiencing the Womb of Woman

THE MANGO SEED

The mango trees

are singing of love

as they sway in sync

in the warm breeze.

One drops its fruit

into my heart

and I carry

its seed

deep

within

as I travel

back to my homeland

whose soil has been dug and raped,

whose soul has been bought with blood

and sold for dollars. Do I dare water

that seed in this tenuous earth?

For it may sprout

and I for sure

will dive

into its sweet

darkness, gentle and

soft as falling rain

filling me with

love and

song.

India / United States

TAKE BACK OUR WOMBS

Indigenous peoples know rape, forced sterilization.
President Andrew Jackson is heard to say,
Rape the Indian out of them, while his churches
raped their spirit, raped their wisdom, raped their culture,
raped their dignity out of them. Or tried.

Neanderthals were mated and likely raped,
after centuries they disappeared, only to be
rediscovered today in our own DNA.
In Congo massacres, known by many women today—
their tribal ways washed away in semen.

All over the world women everywhere
have wombs stolen by rape,
their lineages clouded, diluted,
thinned with the liquid of others.

And now, today, courts have reversed Roe vs Wade,
once our savior. States now have seized control
over women's wombs. Republicans undemocratically
have tugged and fought for our wombs.
The Christian Right has taken control
over our wombs with votes, with banners,
with slogans; controlled by the voice of their God,
their God of old with the breath of wrath.

Women, it is time to take back our wombs,
take back our voices that have been stolen.
Take back our rights as human beings.
Women everywhere; black, brown, yellow, red, white,
Muslim, Christen, Jew, Hindu, Agnostic, Atheist, Indigenous
UNITE IN ONE VOICE: TAKE BACK OUR WOMBS!

Santa Fe, New Mexico

24. Step Out and Be Free

LOVE SONG

(song)

Looking in your eyes,
I let you fill me with a hope.
But then your love withdrew
and left me with confusion.

In my loneliness and knowing
there was nowhere I could go
I found the key within
to unlock space
within the boundaries
of this form.

Down through
the corridors of mind
into the center of my heart
this space of light unites
a world of glowing sea.

It is not far,
not separate from this hand.
It is the space in every cell.
It is the spirit within matter,
within stone,
a world within this world.

Love, come with me,
I want to take you,
show you my real home,
real flesh,
a body you can enter
with a love that breaks
the boundaries
of dark separateness.

Arcosanti, Arizona

TIME, SPACE, STILNESS

"We don't understand your way of life."

. . .broken down trailer, no toilet, no running water, no heat or light,
stationed in the wilderness, Boney Mountain sacred to Chumash Indians,
caves with pictographs of thoughts long forgotten, sunsets over
the Pacific Ocean, a lone Condor nesting in the back bone stone citadels
of the mountains dreaming of his mate who never comes.

"We don't understand the way you live."

. . .time, space, silence with nature's arms around me, showing me each day
the wisdom of 4 ½ billion years of creation, time to sculpt, to write, to meditate
on the joy of life itself, and to dream the call of futures yet unborn.

"We don't understand your life."

. . .and now, the desert arms are holding me on top of a mesa
with 360 degrees view of our sacred mountains; Sangre de Christo, Sandias,
Jemez Mountains with Chicoma's sacred triangle glistening with snow, waking up
to chatter of ravens, following the elk tracks to find him drinking from the spring,
enormous antlers dancing in the morning light adorning his massive body.

And today, today we weep, _time_ to weep with our
Ukrainian sisters and brothers, fathers, mothers with children,
and their brave young men, _space_ to plant sunflowers, one two,
three four, five six, and let the _stillness_ grow into a future, still unknown.

Santa Fe, New Mexico

III

SUMMER FRUIT

TIME IS NOW RUNNING OUT
(song)

Time is now running out.
Return to where we belong.
We are the ancient birdpeople
who have lost our wings.

We have grown long fingers
to grasp the gun. Chained
by the things we grasp
we are held in abyss of darkness.

Time is now running out.
Return to where we belong.
Our bird path is boundless freedom
reaching for the sun.

Let go our chains. Embrace
the rain with our wings.
Pierce the wind with our beaks
as we fly over the world.

Joy rises as we soar
to where we belong.
Boundless freedom
is our real name.

Santa Fe, New Mexico

25. Sun at Her Forehead and Moon at Her Feet

RESTLESS

Men and women of earth
restless with the mess on our planet
mindlessly journey into space.

We easily close our eyes
to poverty on earth,
to thousands of people living
on streets of Los Angeles;
high rents, lack of jobs.

Our minds roam from earth
widening home by lassoing moons and stars
leaving behind a trail of trash in space,
leaving behind the memories
of our children and our children's children
without potable water to drink, without
uncontaminated earth to grow food,
without a nourishing home and
love from a mom and dad.

Oh mind, oh heart,
what have we done in the name of progress?

Santa Fe, New Mexico

ONE MORNING BY THE RIVER

 \mathcal{W} alking down the stony path to the Agua Fria River in Arizona I carry a lightness and joy in my gait, then sit down on its bank by my favorite sandstone boulder. My dream from last night is still imprinted in my body and floats through my mind as I continue to gaze on the flowing water. In my dream I felt a plug pulled out at the base of my spine and the kundalini energy arose as I woke. I heard myself say out loud, "I embrace you Matrix, Great Goddess of the Universe." In my half dream, half-awakened state, I saw my arms rise in an upward embrace like the statues from Neolithic times. I heard the music I have been listening to every day, the tape I play over and over: Russian sacred music, a choir that touches my soul and enters this place of the dream.

I usually wake up chanting my mantra that Swami Prabhavananda gave me when I was nine years old, but this was different. It was as if I was listening to the primal sound vibration buzzing though every particle of life in the cosmos. Perhaps it was the same sound that the ancient seers heard and coined as OM. In my half dream state Ramakrishna's face appeared in front of me. But it felt too limited a form. Even with my passionate love for him, a love that has been with me since I was a child, I felt boxed in. And with the force of my choked spirit, his face burst and I was released into an open expanse, into the consciousness that IS Ramakrishna, and this consciousness expanded to become the All. I heard an OM in the vibrations of myself-the-Universe. My hands and feet tingled and floated away from me. A subtle body of myself was moving in waves of the universe. Joy!

The cool morning air brings me back to the riverbanks as I continue to gaze into the rippling water finding its way over rounded stones. Then the dream of last night begins to play again before me and I see a web of light running as veins through my arms and legs, through the cliffs in front of me, through the river, and the sky above me. I see my form as part of a web of light, for a moment in time, yet I know at this moment that I always existed and will always exist and I have always been a part of the web as veins of spirit running through all of time and before time and after time. For a moment, this lifetime, I have also taken form within this web as a vortex of qualities, condensed chi, a pinpoint in the illusion of shared time. From one standpoint my form is like a blemish in the void. I am pulsing now with the breath of the universe that existed before and will continue after "Vijali," this illusionary form is dissolved back into No Time, unchanged, as ever the primal essence, Brahman, the Infinite Spirit, which pervades all.

For a moment, the thought of a friend arriving later in the week broke my reverie. Then instead of feeling irritated with this distracting thought, as I usually experience it during a time of meditation, I see it rise out of the web and dissolve back into it, return to its

source, its base. The thought is only a part of the breathing in and out of space, a rising of the chest, a letting fall again. It does not take away from the web, it is contained within it. Space within form. And form within space. I can see how the grasping of the thought not the thought itself is the stuck place I have lived in. The thought itself is not the problem. The grasping of thought is like trying to hold onto a piece of the web in my mistake of thinking it is solid, that IT is what is permanent, that IT is the whole. Not even the atoms are permanent. Matter is a stage in an ongoing dance of energy. Oh, world, it is not you that is Maya, the great illusion, as the Hindus believe today. It is just our misunderstanding of what you are, that is the illusion. You are real, and alive and spirit-filled body and matter.

The series of sculptures I have been creating for years, "Spirit within Matter," or closer still, "Spirit and Matter Are One," was an attempt to communicate this knowing. My choice of using the craggy boulders was to represent this basic matter and the carved and painted blue, open sky shape within the boulder represented spirit within matter, space within form. This extended consciousness has sometimes been connected with religion and put off as otherworldly. I am trying to convey that it is not otherworldly at all. It is the very essence of this world. It is not separate. It is within matter, within form and can be experienced simultaneously. It is right here, closer than our own flesh. Spirit/energy/space is the common denominator running through and uniting all. The confusion comes when we project our conditioned, limited, distorted idea of reality onto matter/spirit. We crown some matter with more importance than other matter. When seeing all as God, as Brahman, as the Web of Life connecting all life, can this mud at my feet on the bank of this flowing river be less important than gold?

As I leave my seat of contemplation by the stream and walk by the river, my heart is wringing and wants an answer. How do I write, how do I paint or sculpt this knowing? I see so clearly our real nature, how we are put together and function. It seems so simple, so obvious at times. We are cells within a larger conscious, knowing body. God is the total knowing organism, the matrix of the cosmos. My own cells contain this knowing. Science is telling us today, "the history of the universe is burnt into the heart of every atom." We don't need gurus. We need only to listen to our own heartbeat. To live in this knowledge and to communicate its essence is the purpose of my life here on this earth. It is not a mission given by God, if He does exist in the Christian sense, or some force outside of myself. It is simply the only way to live when we reach the age of maturity. No one is special in this. We don't need a Son of God to tell us these things. We are ALL daughters and sons of the same Truth of the cosmos.

An elder once told me, "we must not connect with astrology but earth wisdom, we are earth beings." Also, one day when a friend saw what I was writing about the

World Wheel, my global art project, he said, "we are on the earth, let's leave the universe out of it." But we now can only understand the earth fully by understanding the nature of the universe. The astronomer Allan Sandage said, "every bone can be traced back to the beginnings of the universe." Science is pushing us in this direction whether we want it or not, as it discovers more and more how we are intrinsically connected, shaped, and sustained by the nature of the universe.

I feel I was not born Native American for a reason, although my heart loves the directness of life, the sacredness of earth, and the vision for community and for the children in the Native American philosophy. Because of my love for these principles, I would have been caught up in preserving this one culture. And that is not what I am to do. For me, it can be nothing short of the universal truth, the perennial philosophy as Aldous Huxley terms it, that breaks the boundaries of all religions and cultures and ethnic upbringing. The universe is my root and my body was given to me through the daughter of the universe, the earth. I am interested in the heritage that contains all heritages.

The heart wants to share. I feel my life is wasted if I can't communicate these roots of us all. I am in agony for breath, as if held under water, as if death is imminent. This is where my mind dwells, but can I put this in a book? It is not entertaining. How do I present the anguish of my heart? There is no conversation that I want to hold with anyone. I would be deemed crazy if I really spoke my mind.

The thought of social exchange is repulsive to me now: to compromise, to say anything less; and I know I don't have the words to express my heart's perception. Perhaps I never will. Perhaps I am destined to live in mute silence. The universe has been kind in this one respect, in giving me this quiet farm cottage by the river without social obligations. With a few repairs in exchange, I have a roof over my head and I still have enough money for food, at least for a while, and a computer at my fingertips. My response to the sound of the wind, the river which in these summer months is a gurgling stream, and yesterday's electrical storm that comes in these hot August days, sending a flash of lightning, my namesake, down the metal gate, four yards away, is my only conversation. I want nothing more than this outward silence and nature's dialogue to allow an inner conversation to surface and dreams to lead me.

A prayer arises as the sun rises higher in the sky and I start to walk back along the stony path toward the farm cottage: "universe, if you want this book of my heart to be written, please, Waves of the Cosmos, move through me in the form of words. If you don't want it written please make it clear to me and I will stop writing." Immediately what comes bouncing back to me is, "Don't worry, in its time it will come. Keep meditating; keep dreaming; keep walking; keep writing."

I HAVE NO NAME

I have no name, yet you
may call me any name.

My grandparents are the stars.
From mother earth I come.
My mate is piercing wind,
caressing cool,
sometimes
burning
hot.
My brothers and my sisters
are wild animals and plants
that drink from earth.
My aunts and uncles
are the trees,
my teachers.
Rocks—my guardians
silently watch, recording life.
My friends the birds, messengers of peace
are now warning of the changes of our earth.
Earthquakes, tsunamis are givers of equality.
Coronavirus is snatching, one by one, one by one,
the earth healing herself from our over population.
Rivers' water, my blood, pouring into oceans now
filled with plastics killing whales, the coral reefs.
The valleys are my womb as I cry out. Oh
mountains; you my pregnancy of the
unknown. And universe—
you are my ancestors
now weeping
with the plight of
your children's child.

I have no name, yet you
may call me any name.

West Bengal, India

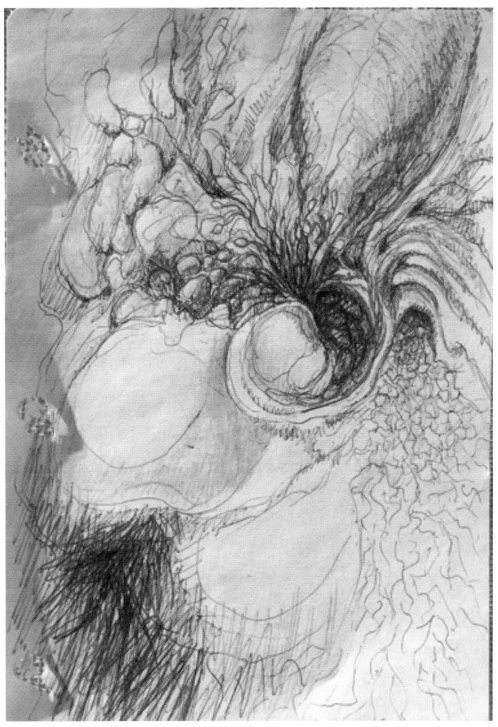

26. Organic Life

FROM THE DARK OF THE FOREST

From the dark of the Amazon forest
arrows of jealous desire shoot through
the darkness of trees, to penetrate her back,
reaching her blood, her bone, until
the arrows find her marrow of space.

Her only protection is the shedding of fear,
like a cloak that falls to the ground
revealing a shining shoulder and back,
like a river that once was frozen,
but now melts with the coming of spring.

Oh, how can an arrow hurt nothingness.
She raises her head above fear
into that spacious sky where
stars light any remains of shadow.

Amazon, Ecuador

27. Transform

BOUNDLESS

Boundless
is my gaze in You,
diving deep into Your sea flesh
through coral reef and seaweed,
though shipwreck and teeth of shark
to find Your feet under all, planted
in the water's blue body of life,
birth of all and home of the
b o u n d l e s s.

WOMB OF STILLNESS

In that
moment as the moon
rose from behind the mountain,
the longing of her soul rose to her lips
and she cried out in her agony. Then
the moon disappeared behind a cloud,
and she was drawn into the womb
of stillness. Luminous light
surrounded her as if she
had just given birth
to the moon
within
her.

Santa Fe, New Mexico

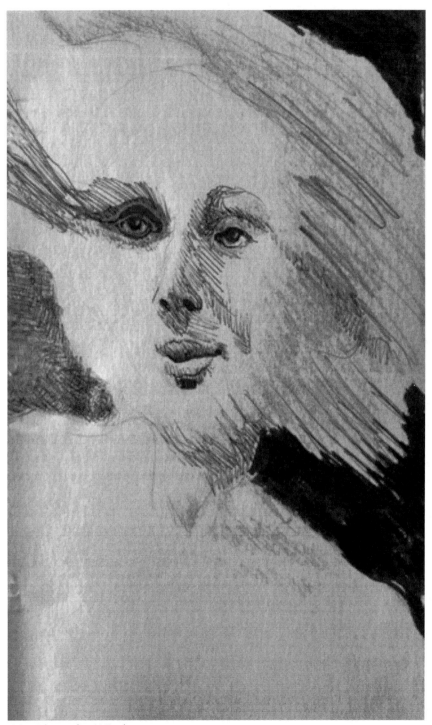

28. Blown by Wind

TIME—STAND STILL

Rain leans forward with wind,
touches my face, wet fingers
uncovering my longing to be silent
like an eagle souring over mountaintops.

I can feel it now, cool air
between fingers wedged into silence,
space between thoughts, grounded only
to rest in nest at top of a ponderosa pine.

Days fly past in my rush of activity,
and I cannot hear earth's gratefulness to sky
as dry desert soaks up this wet gift from heaven.

Time—stand still for me,
I want to hear the conversation
between trees, between squirrels and beetles,
between birdsong and my restless heart.

Time—stand still for one moment
so I can sink my hands into moist earth,
feel rain filling my breast of longing,
cleansing my clouded eyes to their innate vision.

Santa Fe, New Mexico

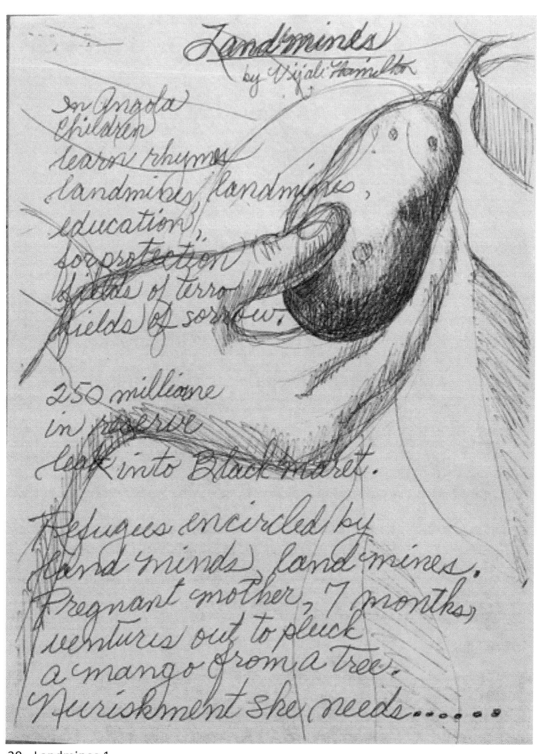

Landmines
by Vijali Hamilton

In Angola
children
learn rhymes
landmines, landmines,
education,
soproduction
fields of terror
fields of sorrow.

250 millions
in reserve
leak into Black market.

Refugees encircled by
land mines, land mines,
Pregnant mother, 7 months,
ventures out to pluck
a mango from a tree.
Nourishment she needs......

29. Landmines 1

now lies in hospital
one leg being amputated
giving birth to tiny baby.
www. landmines . org
Landmines , landmines .

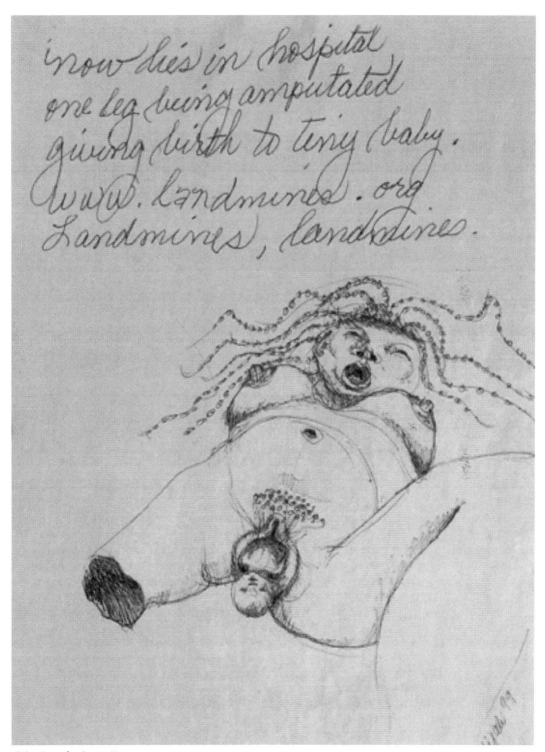

30. Landmines II

VIRGIN MARY BECOMES A WOMAN

Joseph's hand finds her thigh,
swaddling clothes rip open wide,
bedframe moans in rhythm to goodbyes.
Mary rises from the sheets in her torn
blue dress, a virgin she is no more.

He sees her shadow move into the kitchen,
her beauty burnt by flames of his desire.
She fixes breakfast, eggs and bacon,
toast and coffee steaming.

Oh, Virgin Mary, full of grace,
falling from your static throne
your vale is rent asunder as
we see your true form and face.

We see your arms stretch wide
to lift us women in your grace,
your voice of power you now can give us,
your caring heart sings our beauty,
with open hands
you lift us up to kneel no more.

But, a strong woman
Joseph does not want.
He kicks the breakfast table leg,
"Where is my favorite mug with coffee?

Where is my napkin in its ring?

Where is my little girl, in sweet surrender?

Where is my Virgin Mary?"

World Wheel Retreat, New Mexico

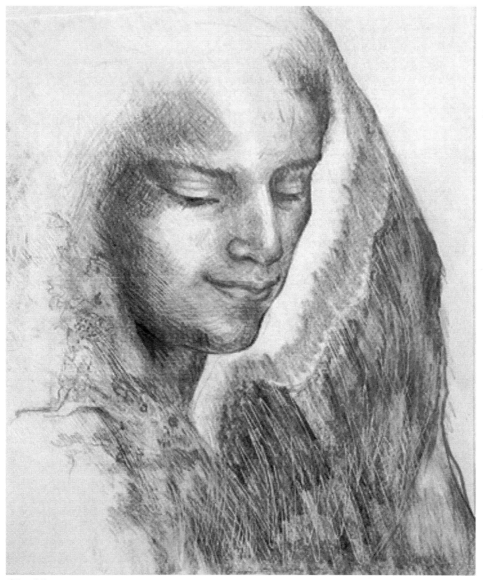

31. Mary

MOUNTAIN LION, FOX AND DEER

Castle Valley, Utah

Wind blows snow across the mesa,
red earth transforms to glistening white.
My first night in this magical wilderness I lay
in my tiny camper with musing thoughts then,
startled, I sit up listening to sound of feet in snow,
crunch-crunch, crunch-crunch circling my new home.
I look out window into dense darkness Just as the moon
begins to show her face and piñon pine and juniper shadows
stretch like fingers across the white desert floor. Purr, purr, purr
I hear, but can't see a form, purr, purr the steady breath continues,
purrr purrr. Not able to see the origin of the breath, I climb into bed
listening to each step, each breath until a tiredness draws me into dream.

The morning pulls me up and out before the sun ascends over mesa. I step from my cubical and find five-inch cat tracks imprinted in snow, a mountain lion circled my camper then walked away. Ah, I have been welcomed into my new home, into the red canyoned earth, into being a neighbor in this mountain lion's habitat home.

One morning in spring as I walk out on the land that so welcomed me, I saw a herd of mule deer on the next rise, peacefully grazing. Joy fills me to the brim and I start dancing, very slowly, as if I was the breeze itself. To my amazement the herd of five deer stop their grazing and stand watching my every movement, transfixed for what seems like a lifetime. I leave so filled with wonder that the whole day carries a joy from the beauty of their presence and our long minutes of communion.

Now it is my gray fox who keeps me company. We sit for half an hour gazing into each other's eyes. Then finally she wrinkles her nose while squinting her eyes, her way of smiling, then curls up four feet away from me, her gesture of acceptance and ease in my presence.

The beginning of our relationship starts one day when this tattered fox, with ribs protruding, torn pelt on her side, one ear sliced half off, fur rough and dull, stands forlorn at a distance, as I move about my day. Pulled by compassion I put out blueberries and an egg, food that I think might be natural for her in the wild.

Every day she comes and accepts my offering. Her breasts are full so I think that she must have a family and had protected her cubs to be in such a tattered condition. Each day she becomes stronger, her coat becomes glossy and her wounds heal. We become fast friends and meditation companions.

82

The weeks go by, then, one day I see something rustle in the bushes behind her. Four little pups shyly peak out between branches. Then they draw courage from their mother's calmness and walk out of the bush towards me. My family has grown and so has my heart. Thinking back now, after many years, tears still come to my eyes. What a wonderful family we have on this magical earth.

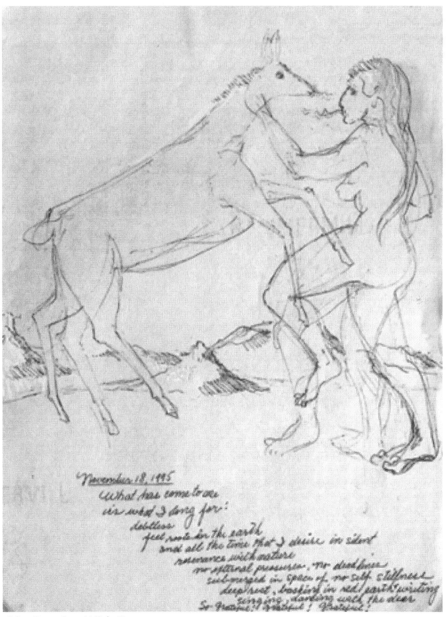

32. Dancing With Deer

SERPENT RISES OUT OF EARTH

 rock head serpent's spine of stone
 through stone rock tail,
 out of earth then disappears
Serpent rises into dreamtime.

Serpent wakes again
 in sunrise with a prayer:
 "See the beauty,
 see the beauty through the sycamore,
 gum, acacia, kangaroo and plum.

See the beauty
 in Dark Man
 walking barefoot
 on this earth,
 Dark Woman
 reading signs from wallaby tracks,
 rabbit fur and eagle's flight."

I drink the cup of sadness and of loss.
Can you break the barrier of silence and of pain?
Can together we drink the cup of spirit and of joy as it flies?

Alice Springs, Australia

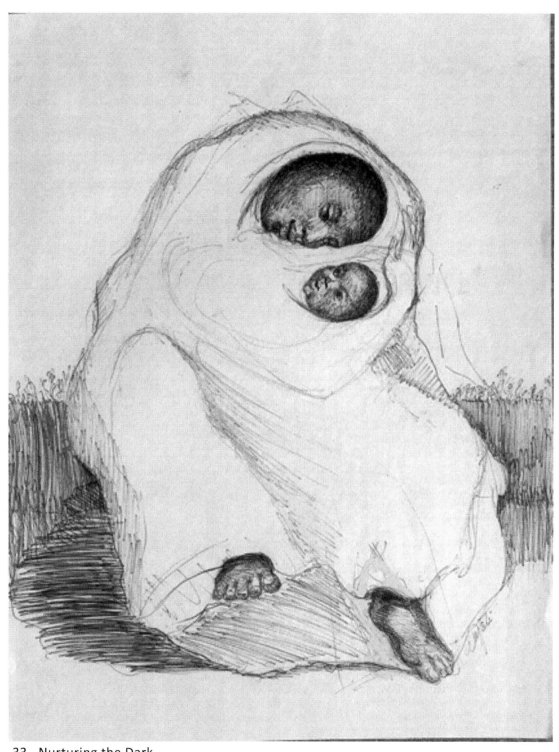

33. Nurturing the Dark

SHINING

Oh

tell me

please tell

me who was it

who walked with me

in that unknowing time of life

when I was searching for love.

Are you the features of One Shining Face?

Oh

my soul,

let me look

out into the world

upon creations that you birthed and

see that same Shining Light through all things.

Santa Fe, New Mexico

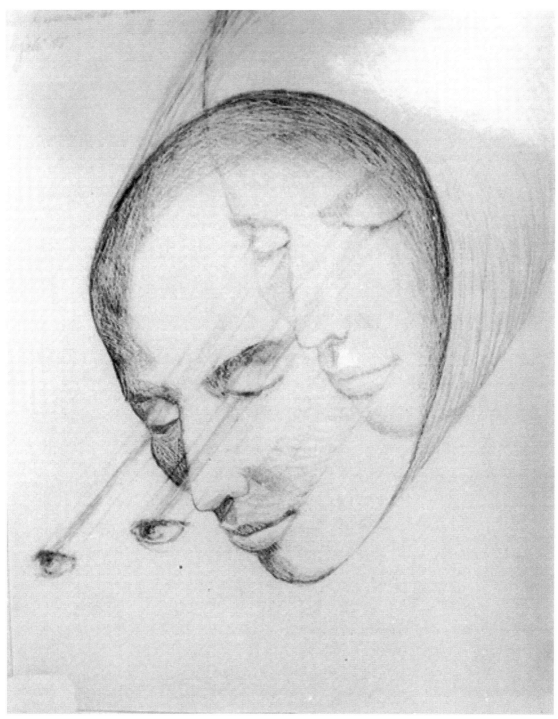

34. Awareness

I AM A FLUTE

I am a flute
w i t h o u t
sound in
the stillness
of night as
t h e m o o n
rises and the
world sleeps
in the day let
me feast on
l i f e a s i t
m o v e s
through me
drinking in
experience
dancing with
sorrow until
it becomes

Santa Fe, New Mexico

WOMAN SING YOUR SONG

(song)

Woman

you came from earth.
Oh sing your song,
and fill our hearts.

Wisdom

is in your hand.
Calm the tides,
bring peace to our lives.

Spirit

ride the winds,
light our minds,
Heal our wounds.

Woman

this is your time.
Heal the earth and mind.
Woman, heal our times,
yes, heal our times.

Santa Monica, California

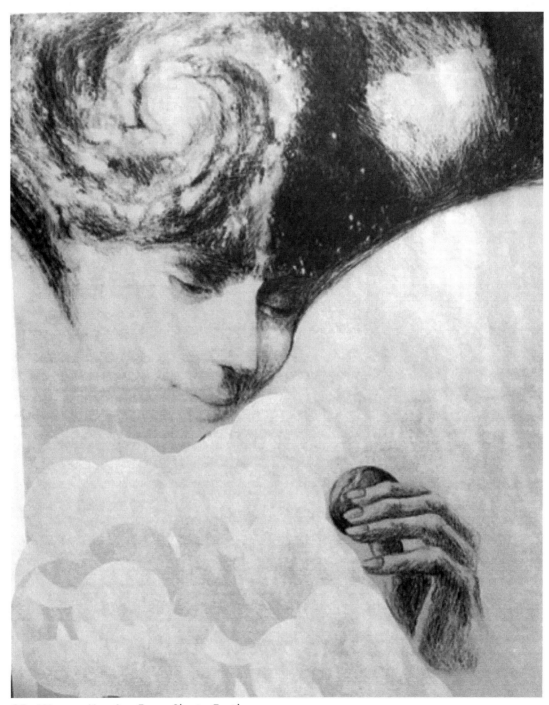

35. Woman You Are From Sky to Earth

FAMILY OF THE EARTH
(song)

I was born a motherless child.

From a dark womb I did come,

but in the trees and in the rivers,

there I found my true home.

So rise up darling from wherever you come:

behind red doors, or work'n in the sun.

Rise up and rejoice my longed-for love,

In our family of the Earth.

My brother the bear, my sister the fox,

my cousin the deer, my butterfly friend,

my longed-for love, my longed-for life,

in our family of the Earth.

I was born a motherless child.

From a dark womb I did come,

but in the trees and in the rivers,

there I found my true home.

Santa Fe, New Mexico

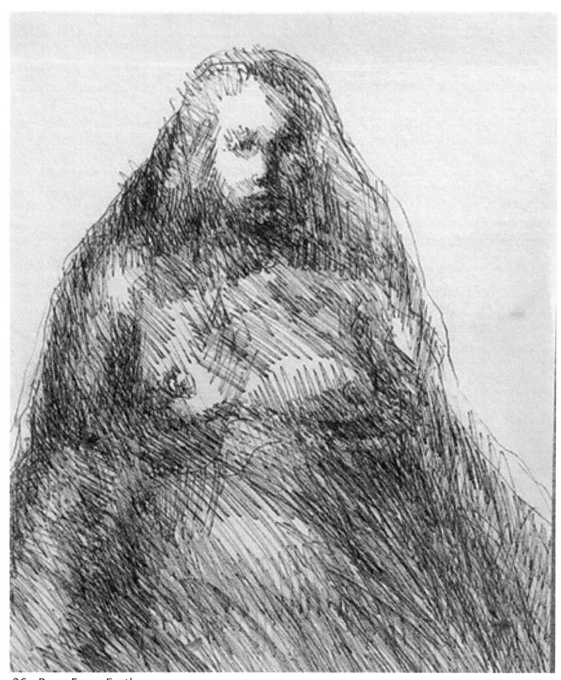

36. Born From Earth

IF I STEPPED OUT OF MY BODY

What if I stepped out of my body,
would I be missed,
or would the world be larger
if my body was left behind?
What is left—the endless unknown
so vast, that I might get lost,
so smooth without pains and stress,
so blue, that the sky feels crowded?

If I stepped out of my body perhaps,
I would find who I really am;
formless, skinless, hairless,
but full of space and surprise,
a breath as deep, or deeper than ocean,
wider than sky, embracing all bodies;
in animal forms, plant forms, mind forms,
in country forms, in earth forms.

If I stepped out of my shell
would the snake be me,
would the toad be me,
would Jonathan be my arms,
would Kenny be my hands?

How much could I embrace;
would my touch be everywhere,
would my sight see all,
would my heart explode
into an endless cry for humanity,
into a trillion voices of longing,
into 10,000 songs of ecstasy?

Santa Fe, New Mexico

93

IV

HARVESTING WISDOM

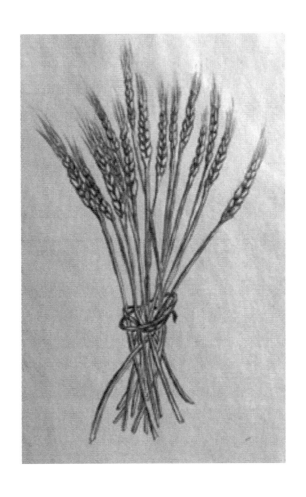

LION WOMAN

the year of the Coronavirus

In the fields of life
I have made myself strong
as a lion, beautiful of face.
Sun giver of life, flame of fire,
come forward in my body,
my divine house. You are
more than the light in temples,

You are my strength inside.

I have made transformations
all at the dictates of my heart.
With my name upon water
may I join Thee who made
me come into being.

I wait for the season of ripening.

With gifts I come before you
to walk among the living.
Come to the fields of life,
lay your grief upon my body
and your heart against mine.
Come, let us make for ourselves
an hour lying down among trees
of juniper and scent of pine, among
stones of granite and a running stream—
our mouths to the earth rejoicing.

Let us live in the company of flames.

Inspired by the Egyptian Book of the Dead and my time in Egypt, 1989. Egypt was a difficult country for me. Traveling alone as a single woman, I was attacked twice. A divine force rose out of myself to protect my life. From the strength I felt, this song has risen to my lips. And because of the strength we need for the protection against the Coronavirus, I feel this poem is appropriate.

37. Of Earth & Fire

MAHA KALI

Maha Kali
the void of throbbing,
invisible dark energy,
womb of our birth.
Without name or
form or time
we began.
Oh
Mother,
you set us on
this journey of
forgetfulness, tears
of desire forgetting our
source, forgetting our
nature of space, the
substance of your
dark flesh.
Until
you draw us
through the ring of
fire, hope and fear,
unto your dark, vast,
timeless lap, we
cannot see
your face
of joy.

West Bengal, India

NO SEARCH

When I desire too strongly to practice a discipline,
be with a teacher, or even think continually
of one person I love like Buddha or Ramakrishna,
a sadness and longing comes wanting union,
wanting a wholeness that is absent.

> When I let go of this feeling of desire,
> of searching, of wanting something,
> a doorway opens and
> I step into spaciousness
> and am already whole and free.
> There is nothing to desire.

Suddenly every moment of life
becomes special and God-filled.
Every person touches my heart in some way
and the company of animals or stones or trees
is as beautiful to me as the company of a friend.
I don't have to be anywhere or with any one person.

> A stillness comes,
> there is nowhere to go,
> nothing to be accomplished.
> The thought of Buddha rises
> luminous in the wild grass at my feet.
> My mantra starts throbs as my heart beat
> in the sound of the river Ganga pounding
> over granite stones on her way to the plains.
> When I sit for meditation I am filled with light like
> the rising sun I see every morning over the Himalayas.

Rishekesh, India, Spring

THE RETURN

It wasn't the World Wheel for Peace, my seven-year journey
 circling the globe with sacred art ceremony. . .
 it wasn't the sunstroke in India that was the most difficult,
 because there were nurturing arms to hold me,
 a hand to steady my brow as I vomited every morsel of food
 that my fevered stomach refused to accept.
It wasn't my money being stolen by a tiny
 darkeyed girl holding her baby that was the most difficult. . .
 or my American Express checks and passport
 being lifted from my belt as we squeezed like sardines
 in the late afternoon bus in Calcutta, or my luggage
 rolling from top of the van in the darkening thunder storm
 as we tossed and turned on the curving roads half washed out
 in the Himalayan Mountains—that was the most difficult.
It wasn't the anaphylactic shock
 from taking bee pollen that was the most difficult. . .
 the near death experience, the swelling lungs,
 the gasping for breath, the tightening skin,
 the smooth purple glaze licking the body,
 and the late night drive through Tokyo streets
 to find a hospital on that first day in Japan. . .
 with Japanese girls who hardly knew my name
 staying with me until I could breathe again
 and their relief as they saw me smile. . .
 then each girl leaving as the sun rose
 to enter her long day of work without sleep.
It wasn't the danger for my life for I was attacked three times,
 once in Spain and twice in Egypt as the smoldering cry burst from my belly
 in an unearthly roar, the cry of all women through centuries untold
 or the befriending of the Coptic hermit in Egypt as he left his cave after 38 years
 of silence telling me of his agony and ecstatic joy in the company of God.

It wasn't the standing alone in the Egyptian desert lost—
that was the most difficult or the not seeing a single object
except sand dunes and sky. . .when a wizened dark-skinned man
emerged like a black beetle against the sea of white sand and
with only a few worlds of English explained his love of life;
by night living in his hovel under the dune,
trapping eagles by day under the vast blue sky.
Then I knew. I understood the tears of joy
in his eyes as he raised his face to the sky to speak.
No, it was not these things that were the most difficult. . .
it was the return to the States, the reentering the days of isolation
with empty streets that looked like set designs
without the roar of life, devoid of children and insane laughter,
but with institutions for birth or death or old age
or for the insane; compartments of life
that no longer nourished each other.

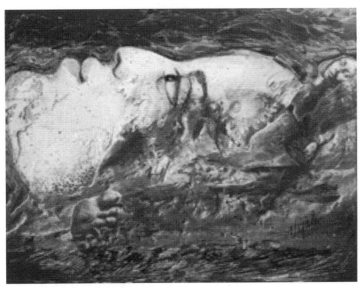

38. The Sea of Disconnect

It was the reaching out for friends who looked in their appointment books to find
a moment to sandwich me in their busy schedules...that was the most difficult.

What I saw and experienced in those seven years
away from my country of birth split the shell of my mind
I grew a new heart that became a boundless heart
while the eyes of each stranger became my borderless eyes
the voice of the trees, the song of the birds became my song
the heartbeat of earth became my own beat
and the music of all living things.
The most difficult is not the journey, but the return. . .
I look into the eyes of my friends
and know that they see in my old way
because they have not left their country. . .
while I know only the feeling of my wings
how the muscles move and stretch
under the curved tip of the feather.

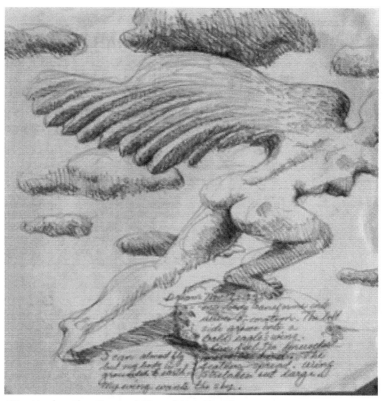

39. Under the Curved Tip of the Feather

NAGA

I
want
to be a Naga
with no clothes
but wearing sacred ash
letting hair grow long
to touch the ground
as I sit by my
sacred fire
Agni.
I
want
to have no
thing only wind and
cold and sun against my skin
tugging at my hair, bathing in river
as I did in Mother Ganga at Rishikesh
eating only what was given me.

I want my tongue silent only
Om tickling mind, caressing skin as I
rest in my beloved cave sheltering
with friends, the bobcat,
deer and
fox.
Oh
mind,
let me rest
at your feet Great Void
on no thing ness filled with sweet life
of essence. I lay myself down at your feet,
lay my bank account down, lay projects down,
lay down music from my heart unsung, paintings unpainted,
lay these at your feet sweet unknown sweet, sweet unknown
bliss of no thing ness shining through every pore every cell, every
moment of not knowing, filled with endless possibilities

as the hand of clock strikes Zero.

Santa Fe, New Mexico

103

17. Organic Man

ANCIENT YOUR STRENGTH

Δ

Ancient

your strength

standing as rock

carved by time

δ

Lava

your blood

volcanic flame

core of your heart

φ

Your

force

f l o w s

relentless

over the earth

as life transforms by

heat of your inner beauty

Boney Mountain, California

WEB OF LIGHT

Web

of light

connecting

shape of leaf

trunk of tree,

basin of water—

Space am I

splattered with red earth,

dancing in harmonic sound.

What shyness is still there,

what hesitancy in my dance,

what shadow creeps across

the free blue sky of my being

in a moment of separation

from the luminous web?

Is it the pill of desire shouting,

drowning out the music of silence,

creating a gulf between me and intimacy?

Boney Mountain, California

41. Refrigerator Poem

42. Woman of Fire

FIRE POEM II

Smell of the fire's excrement

clings to my hair, my hands, my clothes—

reminder, reminder, reminder.

Black Kali, Dark Kali, Night Kali,

you hold in one hand a sword of destruction,

in the other you give me your hand of boons.

Last night you danced wildly into my home.

With fingers of flames you made a black shrine.

I hear you whisper in early mornings,

You—larger than body,

Home—larger than house.

World—your family and home.

Black Kali, Dark Kali, Night Kali.

Castle Valley, Utah

109

BED OF SOUL

Know

the bed of soul

not shaped by time

or sought by map

luminous in each moment

relentless as the river's flow

inevitable as the

sun's rise.

Cerrillos, New Mexico

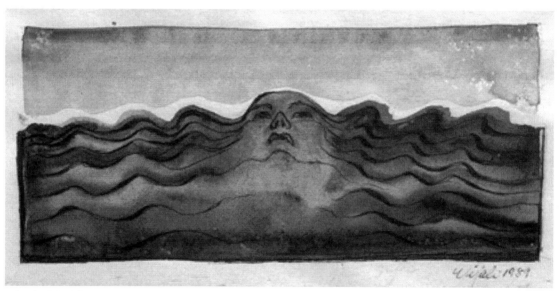

43. Spirit of Water

THIS EVENING

This evening of the turn of fall, crisp and silent, I sit on the porch gazing up at stars. I feel a great presence as if the infinite has come down and wrapped her arms around me, holding me in her warm embrace, protected from the oncoming cold. Some call this presence God, Allah or Shiva. I struggle with the boundaries that these names evoke and at this moment all I can utter with tears streaming down my face is "The Great Mystery," like the indigenous peoples before me uttered while looking up at these same stars. My consciousness is lifted up into the presence of the whole. I am held. I am loved.

This evening as the light fades into dark and the stars take over the sky, my incessant need to struggle with rituals and practices that have occupied my life since the age of nine, evaporates into this rarefied cold air. I am left with the Great Silence that contains the essence of all. Oh silence, oh stillness, I embrace you. You are my true love.

After midnight I go into the hoghan, build a fire and climb into bed. The night is filled with light. It makes no difference if my eyes are open or closed. Waves of light energy, hands of this beloved, engulf me, touching me inside and out until we become one—I fall into the sleep of the great silence.

44. Light

EMPTINESS FILLS

Vast days with no plans—
these are my favorite.
Emptiness that fills
so mysteriously from nowhere,
surprises from the infinite
blossom into moments unforgettable.

Morning arrives,
a red-breasted bird
ventures to my windowsill
bringing beauty into this day.

The phone rings and Greg
with choked voice speaks of his
father's passing last night in sleep,
my former husband, 93 years old
released finally from his bedridden
prison of immobility.

His spirit, on the same wave as
the red-breasted bird, arrives
this moment on the current
of wind blowing through the window.

Perhaps the same incidents happened
to a Neanderthal thousands of years ago
when a bird sat on a stone at the opening
of her cave when she received news of her
partner's death from the tusk of a mastodon.

What song is left in the atmosphere
carried by a future wind? What tears leave
a trace of salt deposited on a stone ledge?
What sadness is caught in a spider's web lifted
by a breeze, settling in the apron of a young girl
10,000 years from now?

Santa Fe, New Mexico

NIGHT FALLS

Night falls and cars are silenced
as sounds of katydids fill the dark.
The mind becomes animal
and lets the body rest as if
curled against warm furry kin—
while something inside is stirred,
takes over and stalks
the spaciousness of the world
in confidence that this is home,
familiar to the touch
of the finger and the tongue,
familiar in the change of pace.

Jangly nerve ends heal.
Breath deepens.
A song rises with every footstep,
a song long forgotten.

Night on the Mesa
Los Cerrillos, New Mexico

THE WIND BLOWS NORTH

The wind blows north today.
Brambles tumble and take flight.
Sparrows' nests loosen from their perch
and the barn door bangs in rhythm
to the breath of wind.

How my heart turns to the north
cooling from the summer heat,
from the passion once ignited
to the cool light of winter's day.
Oh song once sung through my lips
now laid to rest in my heart.

What lays ahead in the unknown,
now makes me tremble but wakes me
to the land of reality, seeing the
plants shrivel and die quietly
as if the turning is not new to them.

Oh heart, may you know truth.
May you accept the seasons as
they come and go.
May you live in joy knowing.
May peace finally settle on
my limbs as my eyes close.

On the Mesa, Los Cerrillos
New Mexico

UNLOCK FORM INTO SPACIOUSNESS

Flowers bloom
a golden hillside.
Mountain gallery
sets stone sculpture
in blueness of the sky.

End of day
when tools are set aside
the warm rose air,
the breath of sinking sun
then gently cloaks
my restless heart.

What is this awe I feel
beyond the changing
chemistry of mind
that unlocks silence into form
and form back to a spaciousness?

Boney Mountain, California

45. Formless into Form

SILENT FACE

I go into nature alone, as
I put the rushing world aside
and enter the forests and deserts,
enter the stones and running streams and
fecund earth, arms of trees and spacious night sky
to lay down all striving, all possessing, all seeking,
and greet the silent face of my still mind.

There, I meet my true love in
the stillness, embraced
by the infinite, filled
to the brim
with joy.

World Wheel Retreat, New Mexico

46. Silent Face

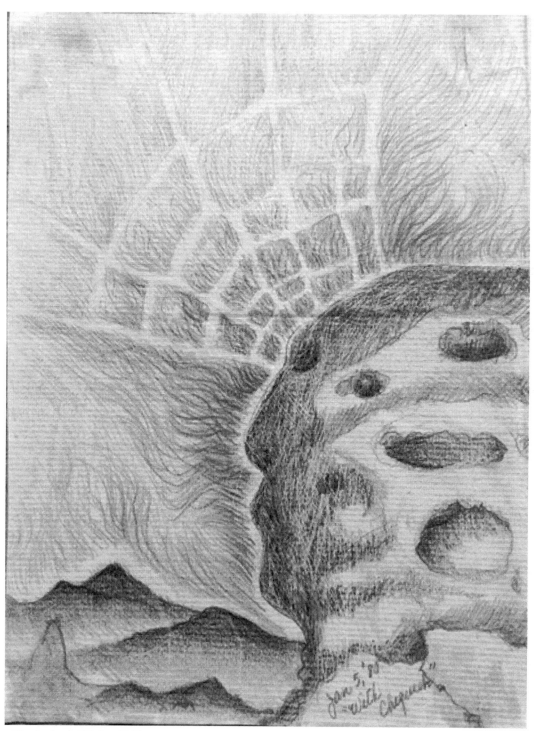

47. Indra's Web of Life

INDRA'S NET
Reflections on the Web of Life

This moment in time is crucial to alleviating human suffering and global misunderstanding through learning to truly cherish one another.

We must dispel our misunderstanding that we are separate beings. It is this misunderstanding that rationalizes global conflicts and oppression of those who seem different from ourselves. This moment is one of great urgency in the face of starvation and suffering of millions in Afghanistan, the continued starvation of children in Yemen and that of undernourished children in the United States. It is a moment witnessing the killing of young African American boys and fathers, and the young Muslim chef, Zahir, in his modest Afghan restaurant. The list extends worldwide with more and more people becoming homeless and countryless refugees teeming at unwelcoming shores.

My message is the same as the sentiment of the Iroquois Peacemaker, Deganawidah, who spoke to intertribal strife hundreds of years ago. The focus of his message was that of a "good or new mind," leading to peacefulness and wellness. Today, we all desperately need such a "New Mind."

The Peacemaker brought his message to five sparring native peoples in the future north-eastern United States. Through his vision was formed the Iroquois Confederacy, which has lasted until today, during an era of European dominance. Ironically, America's founding fathers had come to pattern our own constitution based on the founding principles of the Iroquois Confederacy.

Our future New Mind must embody what it means to be embracing human beings. We have been living under the misunderstanding that we are separate, autonomous beings, mistakenly needing to protect ourselves, our property, our country against the "other." When in fact, as our physicists have discovered, we are intimately interconnected with one another, as we are with the mother earth of trees, animals, fish and fowl, water and air. We are intrinsically a vital part of the web of life that not only connects us with all that is on this earth, but also with the very cosmos itself. I lift my finger, and the whole world is moved.

We have now experienced this reality during the recent coronavirus pandemic. In order to stop this virus from spreading and ravaging, we all bear a responsibility. We are part of the person sitting next to us, as we are connected to the weeping women of Afghanistan. Global warming is both our making and our fate. The melting glaciers on

mountain summits and at the poles affect all life on our planet, and even ourselves in our "climate controlled" homes.

The ancient sages of India knew well the science of the universe. The Atharva Veda preserved this knowledge in the concept of "Indra's Net," which is a metaphor describing the interconnected universe. Indian philosophy illustrates the reliance of all phenomena on one another. Accordingly, each jewel, situated at the infinite knots of Indra's Net, reflects the glow of all its other jewels. It signifies that whether we know it or not, we share each other's fates and fortunes. So, within each jewel is reflected the entire web of life. In the language of modern physics, each jewel or node is part of the quantum potential of our entire universe, of Indra's Net.

And this beholding is what our current moment in time is all about. It is realizing who we really are, that we are inseparable from other human and living relatives, and require action from a wholesome place of knowing, from that of a "new, good mind."

I feel it necessary to tell you of something from my own life, as I sit here with hands on a computer keyboard while speaking to the urgency of mindful change. In the mid 1970s my own perspective had completely changed. A vision, a shift of consciousness, swept over me as I realized that the separations of things, which I had always assumed to be true, were in fact entirely false. I beheld a web of light coursing through my body and into the boulder upon which I was sitting, and through the trees around me and into the sky above. This web of light breathed in and out as if a single, living organism. My own sense of bodily limits dissolved and I merged with this ocean of life into that of a borderless world. This vision has continued to this day to inform my life.

I had lived the first part of my life in great isolation and sorrow, having been abandoned at the age of two. I would weep every night while holding a photo of my mother, who had been committed for life to a mental institution as a schizophrenic. In searching for the roots of my despair, I found solace in the web of life, which connects all. My longing for family grew into my lifelong work, the *World Wheel: Global Peace Through the Arts*, which, in turn, recognized and reinforced all life as a great global family.

What can we each contribute to the world to make a healing difference? I know we all would appreciate some answers. I know how easy it is to feel overwhelmed, experiencing, as we are, the limitations of our lives during world changing events such as the coronavirus pandemic. But we can leave despair behind. We can realize a "New Mind." We can live harmoniously within the web of life, knowing our intrinsic existence within Indra's glorious Net, and we can bring peace into our own hearts, as we awaken in a borderless world.

120

SONG OF THE SPIDER'S WEB

The red rocks above tell their story.
Green shadows in valley below, whisper softly.
Deep purple canyon echoes the past.
Timeless sun on blue horizon, opens our future.

Oh, Spider weaving life, Indra's net,
You caught the jewel of each one of us in Your web.
"Look at my colorful weave," she whispers,
"made from threads of light, containing the pattern of life."

I'm alive! I stand upon the Earth,
hold hands with Light Beings, ancestors, women and men,
children of light breathing in and out
in one song as we share this timeless moment, now.

Wake up and dance, wake up and dance, wake
in another cycle where Sun and Moon harmonize.
It is time! It is time! It is time! Wake up.
Wake up and dance, wake up and dance, wake up!

Canyon de Chelly, Arizona, inspired by friends
watching the solar eclipse and writing together.

AFTERWORD

To echo the voice of the ancient Iroquois Peacemaker, Deganawidah, "we need a New Mind." How can we turn around climate change, how can we ensure that the poor are housed, that children are fed, that our children are nurtured in mind and spirit, that people are welcome in our lives and country who speak different languages, wear different clothes and whose skins are a different color, but worship the same God called by various names?

Perhaps it is my frustration with politics and sadness over the loss of friends that have propelled me to find a voice during this time. The Covid virus is not only a physical virus, but is one of mind and heart. It has taken over our world and earth, leaving our children starving of food, education, guidance in a life where morals, creative inspiration and deep connection with earth have been submerged by materialism.

A New Mind can come by listening to indigenous peoples, observing the deep relationship they have with our Mother Earth, of allowing ourselves the time in native ways to listen and observe what each animal and plant has to teach us as our body goes through the same cycle of sprouting, budding, blooming, and finally turning then falling back as nourishment for new growth to arise.

A New Mind can come by way of an open heart of compassion. Tibetans call this type of person a Bodhisattva, the Indo-Buddhist term for enlightened beings who embody active compassion for the welfare of the world.

It is the embracing of all people and all life, loving others before ourselves, before the accumulation of money and things, and even before our own enlightenment. Let us look toward this ancient wisdom to draw the courage to change our own lives, change our minds, to bring the light of understanding into our world at this highly fraught time in history.

This is my prayer and is always at the base of my creativity, my questioning on what can I do, what little light can I throw into this confused world? What can we each do, each be, each offer at this moment into our beloved world in order to birth the New Mind?

I offer this book as both a path toward my own healing and in quest for healing our times.

LIST OF DRAWINGS
Created from 1972 to 2023

ACKNOWLEDGMENTS

IN GRATITUDE to my dear friends: Peter Gold for his editing of the essays and whose creative essays have inspired my own; Donna Nincic for her editing and creative suggestions; and Mary Neighbour for her editing suggestions on the poems. I want to acknowledge that Patricia Sanders worked with me to form the beautiful essay, *Earth as Sacred Space*, and Jackie Saunders for her design skills, and her patience and knowledge in uploading the book for publication.

1. Poem, *Time is Now Running Out*, Fixed and Free Quarterly, Editor Billy Brown, 2022
2. Poem, *Lava Flows at Our Backs*, to first appeared in the forth coming Anthology of the Museum New Mexico Press, 2023.
3. Poem, *Listen, Fixed* and *Free Quarterly*, Editor Billy Brown, 2022
4. Poems, *The Men I Love, Imprint, It Was Murder, Borderless, Virgin Mary Becomes a Woman*, Fixed and Free Anthology #8, Editor Billy Brown, 2021
5. Poem, *In the Days of Uncertainty*: first appeared in *Suspension*, Volume 3, was made possible by the *Santa Fe Arts and Culture Department's Cares Act COVID Safety Mini Grants for Hope*, 2021. Also it appeared on the online organization: www.Artists4Peace.org.
6. Poem, *Lyon Woman*: first appeared in Lummox Poetry Anthology, Number 9, published by Lummox Press, 2020.
7. Poem, *I Have Made this Choice*: first appeared in Lummox, Number 6, 2017. Also it appeared in, *Listening to Stone, Awakening to the Spiritual in the Natural World*, by Vijali Hamilton, World Wheel Press, 2018.
8. Artwork, *Of Earth & Fire*: first appeared in *Of Earth & Fire*, by Vijali Hamilton, published by World Wheel Press, 2006. Also it appeared in *Listening to Stone, Awakening to the Spiritual in the Natural World*, Published in World Wheel Press, 2018.
9. Artwork, *One With Earth*: first appeared in *Of Earth & Fire*, by Vijali Hamilton, published by World Wheel Press, 2006. Also it appeared in *Listen to Stone, Awakening to the Spiritual in the Natural World*, by Vijali Hamilton, World Wheel Press, 2018.
10. Artwork, *Light*, first appeared in *Of Earth & Fire*, by Vijali Hamilton, World Wheel Press, 2018.
11. Artwork, *Embrace*: first appeared in *Listening to Stone, Awakening to the Spiritual in the Natural World*, Published in World Wheel Press, 2018. Also it appeared in *Of Earth & Fire*, by Vijali Hamilton, published by World Wheel Press, 2006.
12. Artwork, *The Kiss*: first appeared in *World Wheel, One Woman's Quest for Peace*, by Vijali Hamilton, World Wheel Press, 2007.
13. Poem, *Fire 1*, first appeared in Glyphs 11, a poetry anthology published by River Road Press, 2003.
14. Essay, *Earth As Sacred Space*, published in *Skydancer Earthwalker, Womens Pilgrimages to Sacred Places,* ed. by Laila Castle.

Photo: Peter Gold

ARTIST STATEMENT

I remember difficult but significant moments in my childhood. These moments formed the direction of my later life. My mother and father divorced when I was two years old and placed me in childcare homes. When I was six years old I lived for three years with my grandparents. I was dumped into their household and became a problem for them. But when Grandma gave me crayons and paper, it helped me to come out of grief. When I drew, everything was okay and I was happy again. I found a magic power in colors and in the lines I drew. I became friends with insects and stones, and I found my sacred sanctuary in the grasses and rocks of the backyard.

When I was seven, I remember our next-door neighbor being very sad and stressed. She was going through a divorce and was contemplating suicide, as I was told later. With great enthusiasm I drew a picture for her of what I loved, a tree with the sun shining through its branches. When I gave it to her, she took it in her hands and looked intently at it. I saw her whole demeanor immediately change. I could see how it uplifted her spirit. Later Grandma told me that it changed her life at that moment—she decided to live.

I remember that after my grandmother told me about our neighbor's reaction to my drawing I went into my room to ponder it. During those few moments I decided that I would become an artist when I grew up, and I would help people through my art! I wanted to bring joy into other people's lives through my paintings and drawings and show them the beauty of the world around them and perhaps their own inner beauty.

That same year, my grandmother took me to a museum where Navajo childrens' art was being exhibited. One child's art really spoke to me—she was just my age, seven years old. That confirmed to me that this was what my life would be about. The painting touched me deeply and it filled me with hope, to see that a child like me could create such beauty.

Art became my spiritual path. In 1986 I received a dream, to use my art around the world. I would go in a circle along the 35th parallel to show the unity of all people and all life. I named this vision, *World Wheel, Global Peace Through the Arts*. As of now, it has led me to twenty countries to embrace diverse cultures, peoples, religions, and ways of life through my environmental stone sculptures, music, film, poetry, and ceremonial performances. This was, and is, my way to attempt to bring peace, understanding and wellbeing to all I meet. From these two epiphanies in childhood I have dedicated my life as a peacemaker through art to a world without borders.

VIJALI HAMILTON: BIOGRAPHICAL BACKGROUND

Vijali Hamilton is a poet, author, visual and performance artist. Through this synthesis she expands upon the purpose of being an artist. Rather than creating alone in studio, she has fully taken her work out into the world since 1986, circling the globe with her World Wheel Project. She uses the environment and local peoples' creativity as her canvas to convey the underlying interconnectedness of all living beings, with the aim of promoting global healing and peace.

Engaging each community into which she is invited, Vijali and the community collaborate in poetic, art and performance pieces, which address their problems and aspirations. She encourages the creation of environmental and spiritual poetry, sculptures, and murals performances conveying the spirit of their locale and hopes for the future.

In all these instances, a profound healing generally takes place through the magic of collaboration, artistic expression and spiritual communion. Vijali actively continues working into the future with hope for global understanding among individuals, cultures, religions and countries. May they embrace peace in their lives as members of our one earth family.

In 1986 she founded her first World Wheel project, a seven-year spiritual and artistic pilgrimage circling the globe at the 35th parallel in twelve countries. These addressed social and spiritual needs of each community, including gender equality and appreciation of other cultures as relatives in human family.

In 1999 Vijali began her second *World Wheel, Global Peace Through the Arts* journey. The first sites visited were in the Andes and Amazon of Ecuador; Senegal; outback Austral ia, and the Republic of Georgia. She also established a World Wheel Project for homeless youth in Los Angeles, where poetry, sculpture and paintings were created.

Vijali lived for ten years as a monastic member of the Vedanta Society in Santa Barbara. She holds a Masters in Fine Arts degree from Goddard College and is a fellow of the World Academy of Art and Science.

Vijali's books include *World Wheel, One Woman's Quest for Peace* (2007); *Of Earth and Fire* (2006); *Listening to Stone: Awakening to the Spiritual in the Natural World* (2018) and, *Liberty Enlightening the World* (2021).